# AT THE
# WATER'S EDGE
## MUSKOKA'S BOATHOUSES

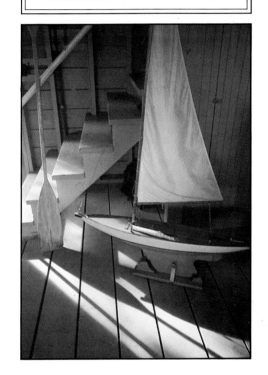

# AT THE
# WATER'S EDGE

## MUSKOKA'S BOATHOUSES

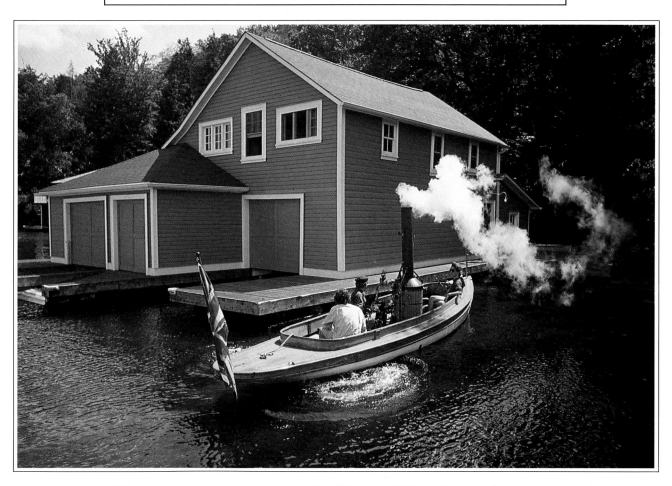

Photographs by John de Visser / Text by Judy Ross

A BOSTON MILLS PRESS BOOK

ACKNOWLEDGEMENTS

*The authors would like to thank all those who allowed us to photograph their boathouses, with special thanks to Douglas McTaggart, Beverley Bailey, Gary Kaye, Madeline and John Fielding, Barry and Jenny Hayes, Don and Dean Mortimer, Robbie Ross and Dodi Robb.*

Canadian Cataloguing in Publication Data

De Visser, John, 1930-
    At the water's edge: Muskoka's boathouses

ISBN 1-55046-082-X hardcover
ISBN 1-55046-075-7 softcover

1. Boathouses – Ontario – Muskoka – Pictorial
works.   I. Ross, Judy, 1942-        II. Title.

NA6920.D47 1993      725'.87'0971316      C93-093616-7

First published in 1993 by
Stoddart Publishing Co. Limited
34 Lesmill Road
Toronto, Canada
M3B 2T6
(416) 445-3333

A BOSTON MILLS PRESS BOOK
The Boston Mills Press
132 Main St.
Erin, Ontario
N0B 1T0

Design by Gillian Stead
Typesetting by Justified Type Inc.
Printed in Singapore

The publisher gratefully acknowledges the support of the Canada Council,
Ontario Ministry of Culture and Communications, Ontario Arts Council
and Ontario Publishing Centre in the development of writing
and publishing in Canada.

OVERLEAF: *After a steam-driven spin, Paul Gockel drifts up to the Woodruff boathouse on Lake Joseph in his 25-foot launch built in 1905.*

FRONT COVER: *Bracken Island, Lake Rosseau.*
BACK COVER: *The Walker boathouse ready for summer.*

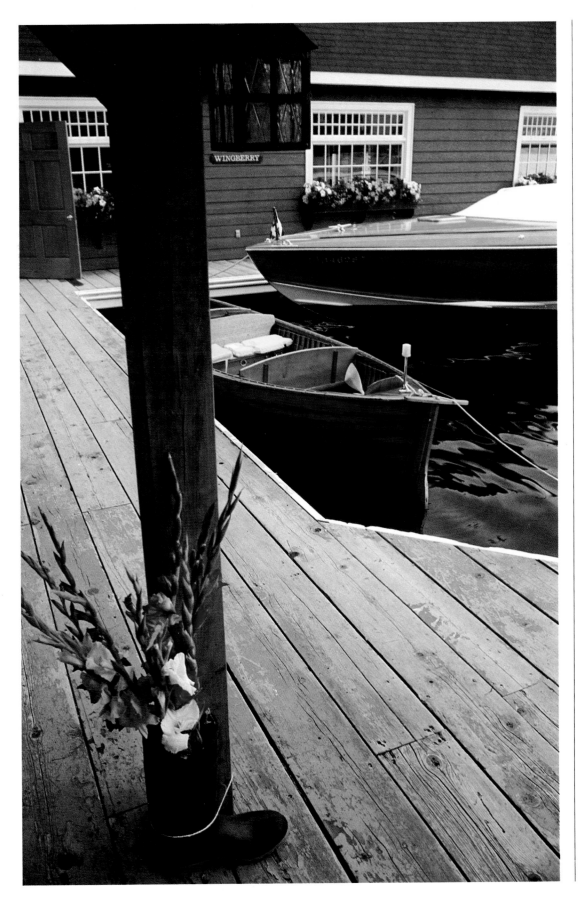

# Table of Contents

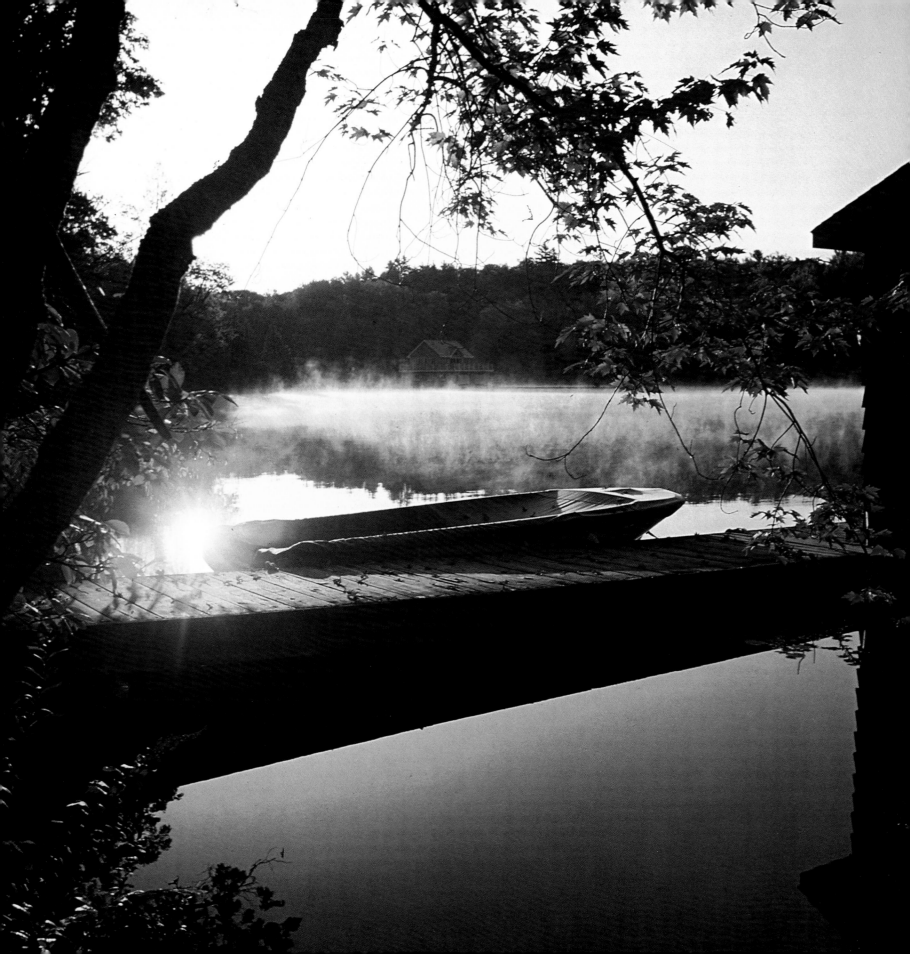

# LIFE IN A BOATHOUSE

My summer days begin when the sun rises over Crown Island on Lake Muskoka. Shafts of sunlight ripple across the lake and bounce off the water into my boathouse bedroom. Without moving from my bed I can see this miracle of day breaking. I get up and put the coffee on. As the boathouse fills with gauzy light, I pad about in bare feet and enjoy the quiet while others continue to sleep.

With warm coffee mug in hand, I make my way outside to water the flowers in the window boxes that line two sides of the boathouse. I pick off dead blossoms, poke at the soil, and breathe in the fresh air, fragrant with pine. The dock underfoot is damp with dew, and the sun is just beginning to drink up the morning mist as I slide into the lake for my ritual morning swim. All is silent, except for a seagull calling to me from the boathouse roof. Treading the soft water a short distance from shore, I watch my cat, the only other creature stirring, as she rounds the corner of the boathouse, crosses a patch of rock, then curls into the base of the cedar tree next to the bird feeder.

This routine happens every summer morning at our island boathouse-cottage in Muskoka. It is my family's treasured retreat. The boathouse is our emotional anchor, the place that roots us, the place to which we all return. I've been coming to these two small islands belonging to my aunt since I was a child — long enough to know every inch of lichen-covered rock, the shoreline's every nook, and the height of every pine tree. Now my daughters perpetuate this loving attachment to our small patch of earth. "Can't we go up just for an hour or two?" my younger daughter implored recently because she hadn't been to the boathouse for months. In our family "go up" has always meant "go up to the lake." The island's cottage has existed, in various forms, for a long time, but our livable boathouse is new. Its construction was an all-consuming project that took place in the summer of 1988.

That was a summer of much building activity around the Muskoka Lakes. A construction boom took place in this cottage country between 1985 and 1990. Property was selling for unprecedented prices and many extravagant new cottages were built with immense boathouses at the water's edge. The last time the lakes experienced such epic boathouse-building was between 1905 and 1930, during Muskoka's steamboat era, when cottagers depended on boats to get to their summer homes. Few roads had been opened into the area, so the early cottagers arrived by train, then boarded the appropriate lake steamers that would carry them and their belongings to their cottages.

In 1905 the Muskoka Lakes Navigation and Hotel Company ran the largest inland-waterway steamboat line in the country, ferrying cottagers and hotel guests from one end of the lakes to the other. Fifty thousand guests could be accommodated at scores of fashionable summer resorts. Many cottage owners found the navigation company's timetable too erratic, so they bought their own steam-driven launches. These launches were large enough to hold family groups with their attendant trunks, wicker baskets, packing

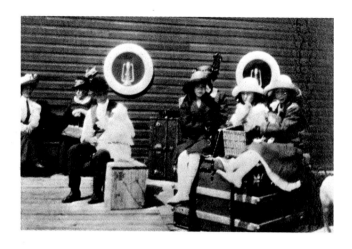

*Many families depended on the commercial steamboats run by the Muskoka Lakes Navigation and Hotel Company to deliver them to and from their cottages. Long delays were inevitable. Here, resplendent in their travelling clothes, a family waits for a steamboat at Browning Island in 1915.*

crates and hat boxes. Some of these private steamers were enormous. The *Wanda II*, for example, was a 94-foot steamer built in 1905 for Timothy Eaton, the Toronto department store tycoon. It could hold fifty passengers. Before long, dozens of private steamers plied the lakes, each requiring a boathouse for shelter.

Before the advent of the steamboat, the only shoreline buildings were crude sheds put up by settlers to store their canoes and rowboats, or the somewhat more elaborate dry-slip boathouses belonging to the cottagers. The latter had ramps that sloped into the water so that unmotorized craft could be pulled out of the lake for winter storage. But when the large new private steamers arrived on the lakes, they required buildings that had long slips and tall, pitched roofs. Sheets of tin were used to cover the ceilings, and smokestacks were cut into the rooftops because the boats' wood-fired engines were stoked while the craft were still in their berths. This hazardous arrangement caused frequent boathouse fires. Many early steam yachts were destroyed this way, including the lovely *Wanda II*, which burnt in a boathouse fire at the Eaton's summer estate on Lake Rosseau in 1914.

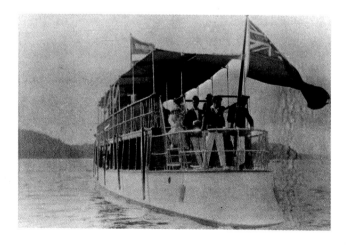

*The Eaton family arrives at the 1921 Muskoka Lakes Association Regatta aboard their private steamer, the* Wanda III.

By their nature, boathouses are intrusions on the landscape. Every one built obliterates another patch of scenic shoreline. But many have architectural merit that goes beyond their function. Architect Tony Marsh, who has been involved in twelve Muskoka boathouse projects, maintains that "the design of the boathouse is more important than the cottage because it's more visible. It's a less serious building, really just a garage for boats, so there's room for some whimsy in the design. Details like fish-scale shingles in the gable ends, trellises and window boxes are what make them interesting as buildings." In the architecture of boathouses, it seems, form can follow fancy.

In the early years, architects were rarely involved in the building of boathouses or cottages. Many turn-of-the-century cottage designs came from pattern books, popular building guides published during the Edwardian era. The one architect known to work in Muskoka around the turn of the century was from Pittsburgh. In the early 1900s Brendan Smith was hired to build cottages and boathouses for a few of the Pittsburgh group who summered at Beaumaris. Most notable are the much-photographed Clemson boathouses that look like big and little brother due to their jaunty matching roof lines and porthole windows. Another Brendan Smith structure is found at the Hillmans' property on Gibraltar Island, where two look-alike brown boathouses with fanciful white trim stand side by side. Both these sets of boathouses were built by Peter Curtis, a local builder who left his trademark in the form of wooden cutouts. At the Clemsons' the cutouts are heart-shaped and can be seen on railings, shutters and dock benches. At the Hillmans' the cutouts are diamond-shaped.

∞

Second storeys were often added to boathouses to accommodate staff. In those early days, families often stayed for the entire summer — mothers and children, assorted grandparents and aunts, cousins and others. Servants ensured the smooth running of such large enterprises. On Lake Muskoka at the turn of the century, James Kuhn, a banker from Pittsburgh, built a huge estate on Belle Isle and then brought to the island a staff of twenty-six, a number of whom lived in the family's boathouse. At some cottages the boathouse's upper storey was used as a dance hall and was festooned with streamers and paper lanterns for Saturday-night parties.

As gasoline-powered motorboats took over from steamboats and steam-powered launches, the need for large waterfront buildings lessened, and from 1930 to 1965 few boathouses were built. Some of the older ones that hadn't burnt or fallen down were altered to get rid of their smokestacks and tall, covered slips. In some cases a floor was added to increase upper-level living space, and because family servants were now a thing of the past, the second storey became dormitory space for the children.

∞

For years boathouses — particularly those located along Millionaires' Row at Beaumaris — have been focal points for afternoon cruises around the lakes. But it wasn't until the early 1980s that there emerged a renewed interest in "Old Muskoka" cottages and boathouses. Muskoka once again became a fashionable summer place, much as it had been during the golden years of the 1920s, when Muskoka events and gatherings were reported weekly in the society columns of Toronto's newspapers.

Many of the old boathouses were restored, and new ones were built to imitate the old style. Upper levels that over the years had become storage space, or recreation rooms for children, were also looked at with renewed interest and in many cases renovated for adults, either as guest rooms or granny flats. "What happened at our boathouse," explains a Lake Joseph cottager, "is that we planned the space perfectly for weekend guests, then spent one night in it ourselves, listening to the water, and never moved back to the cottage."

Living in a boathouse wrapped in blue lake is different from living fixed to the ground in a cottage. There is a feeling of buoyancy in the daytime, and at night the lulling sensation of water lapping beneath you as you sleep. It is like being on a large vessel that is permanently anchored in the same snug harbour. "It gives me a psychological lift," claims a boathouse-dweller from Lake Rosseau. "The light is special. It glints off the water even on the dullest days." The full spectrum of light can be seen. Dawn comes in with its pale and shimmery waves of yellow, and at dusk the afterglow of sunset is like a mauve cocoon.

∞

Summer days are ruled by the lake's many moods — by the rhythms of the water, the cycles of the sun and moon, the closeness of the night sky. Like sailors, boathouse-dwellers study the wind. At our island we're exposed to an open stretch of lake, and at times "the north wind doth blow." And blow. And blow. On such days, as the wind rattles the windows and shakes the foundation cribs, we dismiss all loving thoughts about the place. Curled up in the deep cushions of our sofa, with stacks of books and magazines at our side, we turn up the music to drown out the crashes and thuds. We haven't let the real world intrude on our boathouse in the form of television and VCR, but we do have such civilized comforts as hydro, hot water, telephone and stereo. My kitchen typifies the simplicity of our existence, with its two-burner hot plate and absence of gadgets. We try to balance our boathouse life along the fine line between rusticity and comfort.

In her book *Gift from the Sea*, Anne Morrow Lindbergh wrote about "the art of shedding" and how little one needs for beach living. Boathouse living is, or should be, similar. It demands less. Fewer clothes make their way into limited closet space, furniture is kept simple, and outdoor cooking dictates a casual approach to meals. Being surrounded by a vast, cooling body of water tempers our hot summer days.

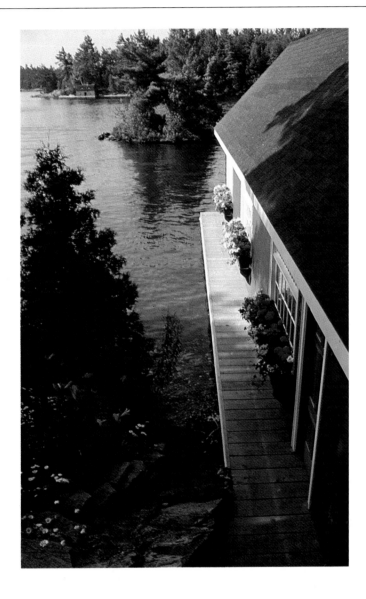

One of my favourite times at the lake is twilight, when my husband and I inch our way out of the boathouse in our old motorboat and put-put along the shore. We watch as the last sliver of daylight disappears from the horizon and the twinkle of cottage lights begins to appear along the shore. As darkness falls and the rush of cool air rises from the lake, we idle back to the boathouse, pull down the door, and bid goodbye to the day.

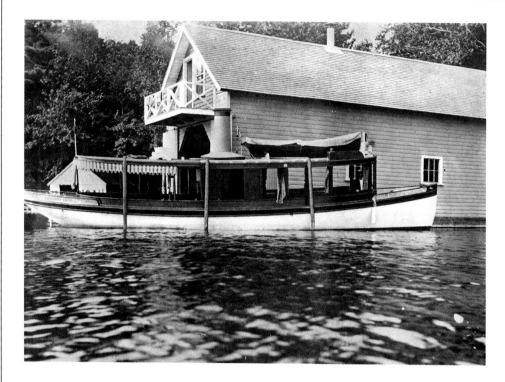

In the early 1900s boathouses were built to shelter the cottagers' steam launches. Back then, when few roads reached the Muskoka area, these canopy-topped steamers were the primary means of transportation, carrying the family and their belongings from the train station wharf to the cottage. Moored at this boathouse in 1906 is Arthur Blachford's steamer Fidelia.

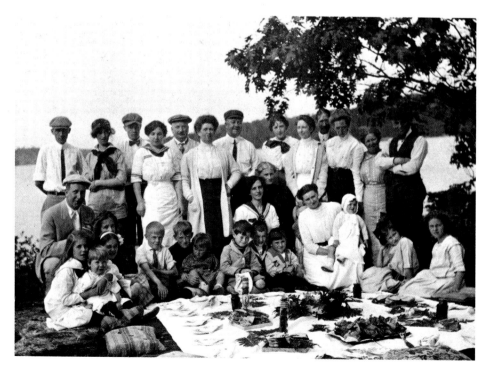

On warm and sunny Sundays, the steamer was loaded with food and taken for a cruise up the lake to a favourite picnic spot. Pictured here is a gathering of the O'Brien clan.

The weekly scribbles in our family diary show how insular our boathouse life becomes. Little of the outside world is noted. Instead there are jottings about the weather; the temperature of the lake ("still too cold for a midnight skinny dip"); the day the swallows arrived and started to nest beneath the eaves; the comings and goings of friends and family ("Jane arrived today with the three kids"); the number of saplings gnawed by the beaver; and details about the size of the moon and its silvery path across the lake. And for each of the four summers that we have lived in the boathouse, the final entry in October reads: "All is drained, antifreezed, emptied and shut down. We hate to leave."

∞

Until 1965, Muskoka boathouses were built without restrictions. No by-laws had been imposed by any government to control the building of these waterfront dwellings. Then, as concern for the vanishing shoreline increased, permits were required and various regulations applied. Now the rules change on an almost yearly basis. But since 1989 the maximum allowable size for boathouse living quarters has been 650 square feet, with a maximum height of 25 feet. The neighbours' approval is required before a permit can be granted. In addition, the Ministry of Natural Resources must examine the lake bed to ensure that fish spawning grounds will not be disturbed by the foundation cribs, and Canadian Coast Guard permission stating that the structure will not impede navigation must also be obtained.

In 1990 the Ministry of Natural Resources began to look even more closely at buildings on Crown lands (which include all waterways) and decreed that no more two-storey boathouses may be built in Ontario waters. Permits will only be granted for single-storey structures. And so the boathouses of Muskoka, these quirky, often elegant harbingers of the cottages that lie hidden in the woods, will become historic treasures, never to be duplicated.

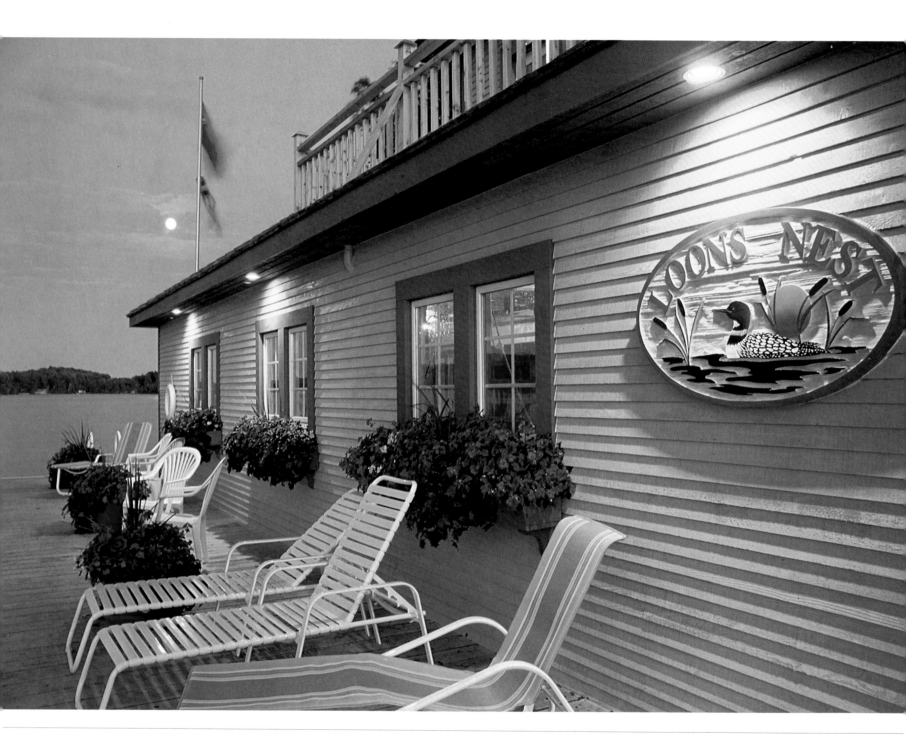

A sandblasted cedar sign identifies
Loon's Nest on Lake Joseph.

# LOON'S NEST

## LAKE JOSEPH

"Building a house on water is different from building a house on land," says Gordon Brown, the contractor who built this Lake Joseph boathouse for Barry and Louise Needler. For one thing, the foundation work takes place in winter on top of a frozen lake. At that time of year the water level is usually two feet lower, so the underwater foundation and the first layer of stringers can be built more easily.

There are two common methods for building the foundation of a boathouse. In the traditional method, a set of cribs, or square log boxes, is assembled using the ice as a building platform. Then a hole the appropriate size is cut in the ice and the crib is lowered into the water. Rocks are poured into the cribs to anchor them to the lake bottom. The number and size of the cribs depends on the square footage of the decking. If built well and protected from the push of ice in winter, these wooden cribs can last indefinitely. Wood that is permanently underwater never rots.

Recently there has been a trend toward the use of a different method called the steel-piling dock system. In this system, steel beams are driven into the lake bottom to form a foundation, instead of using wooden cribs. When building Loon's Nest, Gordon Brown used thirty-two steel piles, some over 30 feet long, to create a 2,600-square-foot dock platform for the boathouse. The upended steel beams were slotted down through holes in the ice and driven through the silt and into the bedrock with a jackhammer. "This system is preferred by the Ministry of Natural Resources," explains Brown, "because it takes up less square footage on the lake bottom and there's less disturbance of fish spawning areas." The foundation work was completed during the winter of 1992 and the structure was in place by June. In honour of two loon families who "wake us up at 2:30 every morning," the Needlers christened the boathouse Loon's Nest. It now shelters a 1929 Ditchburn, *Mowitza*; a fibreglass inboard/ outboard; a kayak; an aluminum runabout; a paddle boat; and a Florida-style 18 1/2-foot Wahoo fishing boat. The 650 square feet of living space upstairs is temporarily being used as storage.

With its sage-grey exterior, cedar roof and blue trim, the boathouse has already mellowed into its surroundings. In the evening, lights beam down from the soffits to create a pleasant glow. Below the deck, quartz-halogen underwater lights illuminate the water like a swimming pool. "These underwater lights are ideal for swimming at night," says Barry Needler. "And for guiding boats home in the dark."

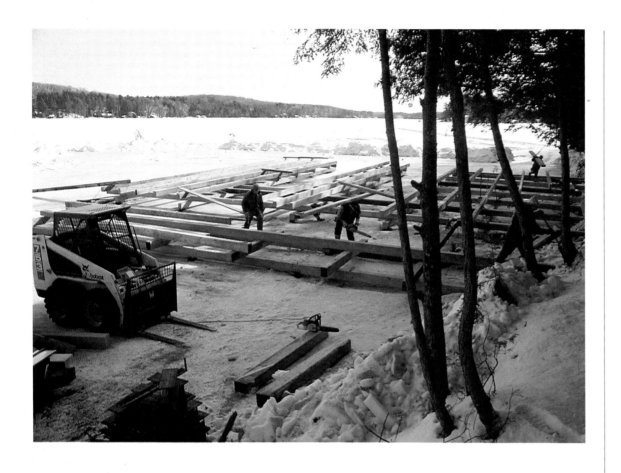

The frozen lake is used as a building platform for installing the boathouse foundation. Steel beams were used instead of conventional cribs in the construction of Loon's Nest.

The spacious interior now houses the Needler fleet. The flagship, seen on the left, is the *Mowitza*, a 1929 Ditchburn.

At night the new boathouse is ablaze in light. Special quartz-halogen underwater lights illuminate the lake water as well.

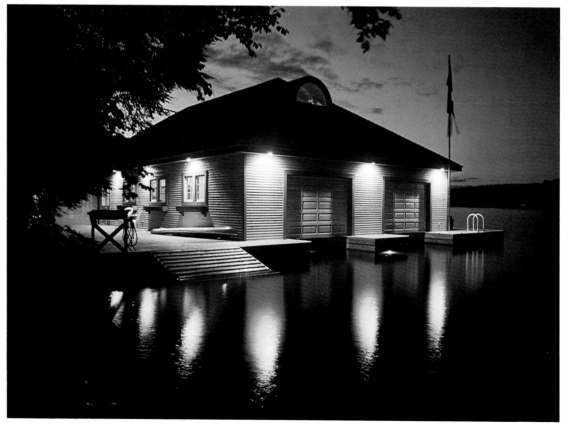

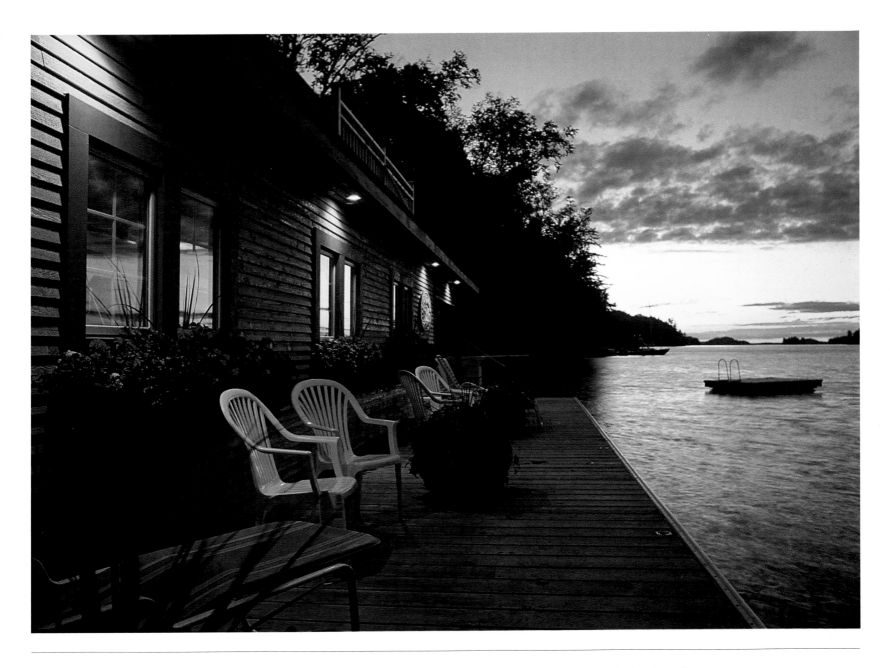

**The afterglow of sunset on Lake Joseph.**

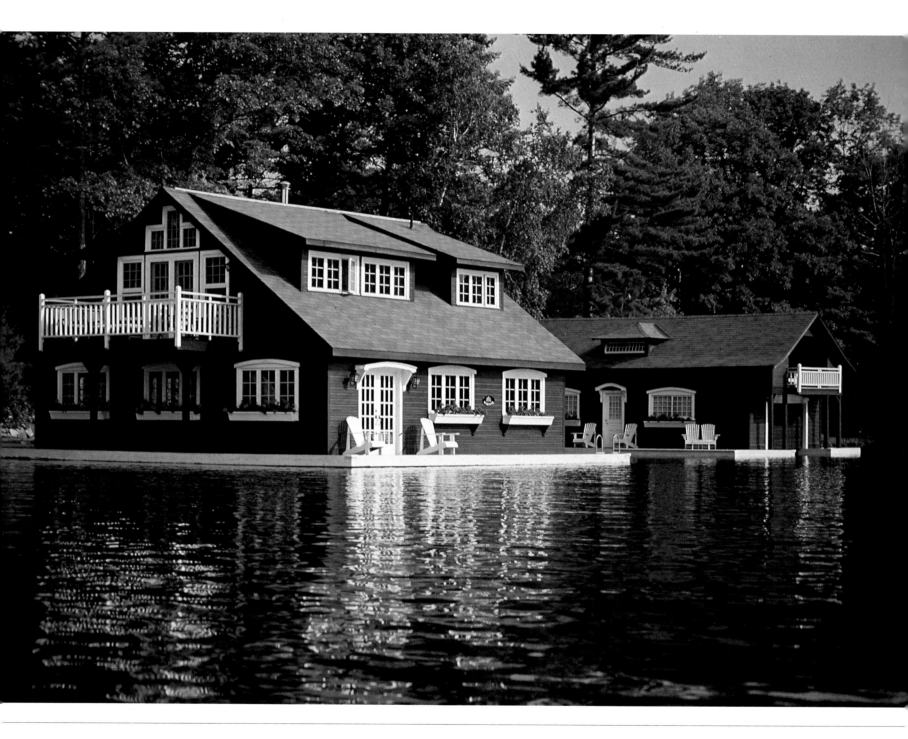

One of these two boathouses was built circa
1920 and the other only two years ago.
The new, larger boathouse has two slips.
The living quarters above are
insulated for winter use.

# KUSKINOOK

LAKE MUSKOKA

An old boathouse once stood leaning lakeward on this narrow channel on Lake Muskoka. It had been there for decades and was on such a slant that just one shove was all it took to knock it down. According to its owner, Arthur Angus, "It was always difficult to land in that boat slip because it faced south and the boats were battered by the wind. When we designed the new boathouse in 1991, we were able to turn it around so the entrance is in the lee of the wind."

Arthur and his wife, Marilyn, wanted their new boathouse to blend into the surroundings, just like the stone-and-shingle cottage up the hill. The cottage and a smaller boathouse, both built in 1923, had been in the Angus family since the 1950s, and Arthur had fond memories of his childhood summers here. For their new boathouse, the Anguses first chose mullioned windows with the same arched lintels and window boxes as the small boathouse. The shed roof dormers are typically Old Muskoka, as is the brown-and-white colour scheme. When the old boathouse came down, about all that could be salvaged was some basswood panelling, which they used to line the new cupboards.

As Marilyn says, "We put a little of the old place back into the new." Even though basswood is soft and scratches easily, the Anguses chose it for the boathouse's interior walls because they liked its light honey colour and because it matched the basswood in the cottage. This was a favourite wood for interior walls back in the busy cottage-building era of the 1920s, and unlike pine, basswood tends to stay light as it ages. Many years ago the cottage was given the name Kuskinook, an Assiniboine word meaning "west wind." Like many of Muskoka's grand old cottages, Kuskinook was not built for winter use, so the Anguses planned to use the new boathouse as their snowy retreat. For their floor-to-ceiling fireplace in the living room, they gathered 2,000 pounds of rock from the property. The cozy living space also has a kitchen, two bedrooms, a bathroom and a walk-out balcony. In the summer it is used as guest quarters, and in the winter, when the old cottage is shuttered up, the Anguses come to this boathouse on weekends, light a fire in the big stone fireplace, and watch the sun set over the frozen lake.

21

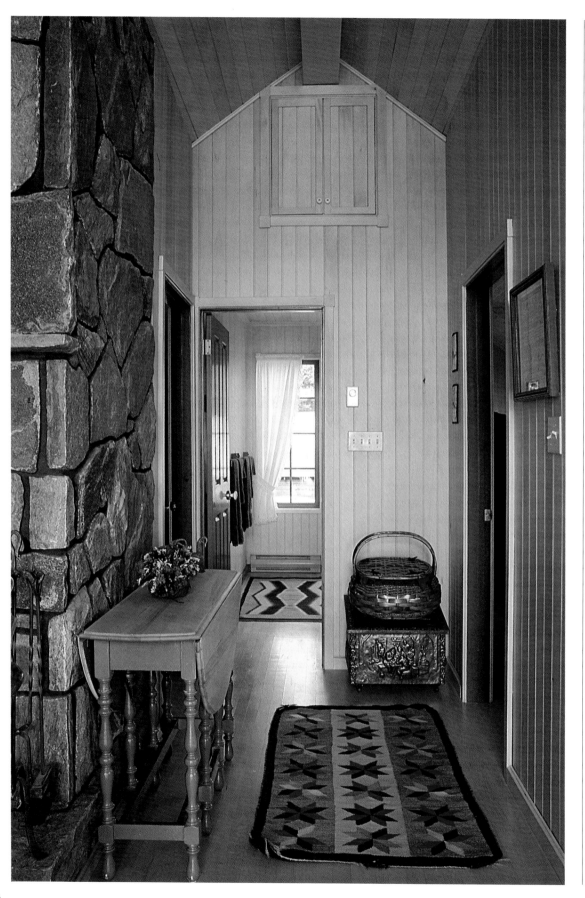

The hallway leads to the two bedrooms and bathroom. In the left corner is the massive Muskoka stone fireplace. The rugs are vintage Navajo, part of a collection of about sixty that was found in the old cottage.

A beamed cathedral ceiling lined with basswood makes the small space seem light and airy. Much of the furniture, like the spool daybed in the corner, came from the attic of the old cottage. New pieces, like the milk-painted coffee table, blend nicely with the old.

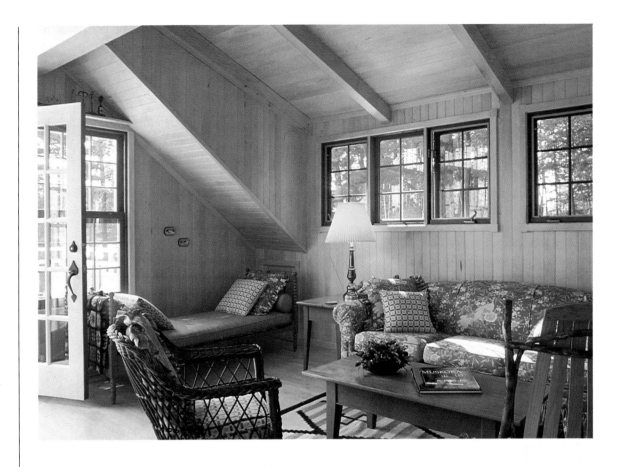

The spool bed, which the Anguses stripped and painted, was part of a collection of treasures in the cottage's attic. Through the window you can see the small boathouse built in 1923.

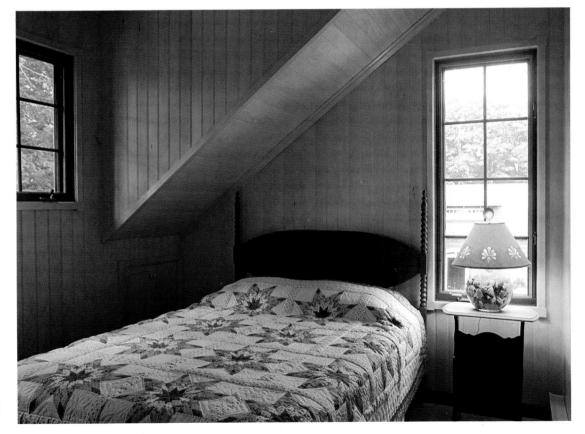

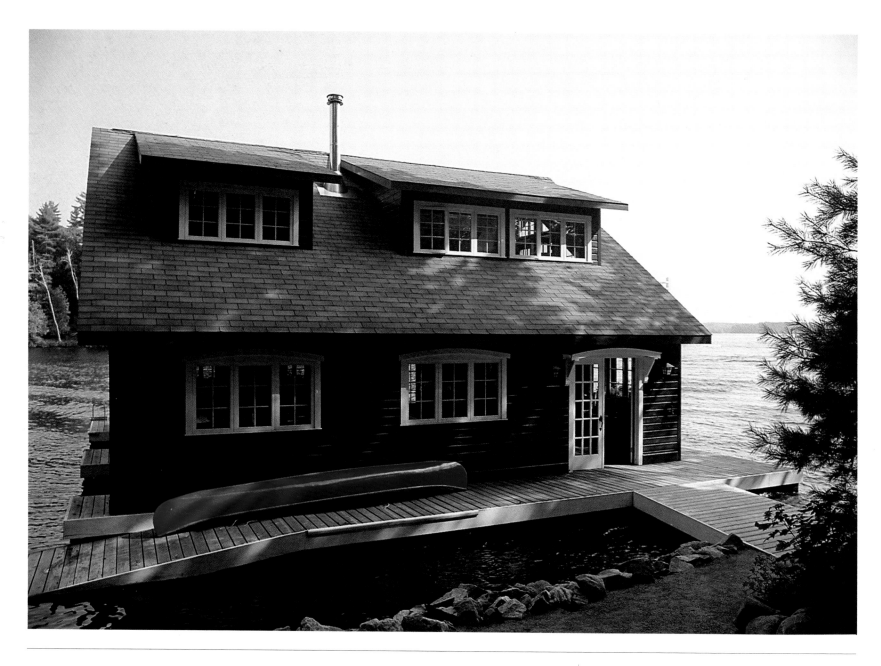

This boathouse emulates Old Muskoka style.
The antique iron lanterns made by The Smithy
at Glen Orchard have yellow light bulbs
that cast a golden glow at night.

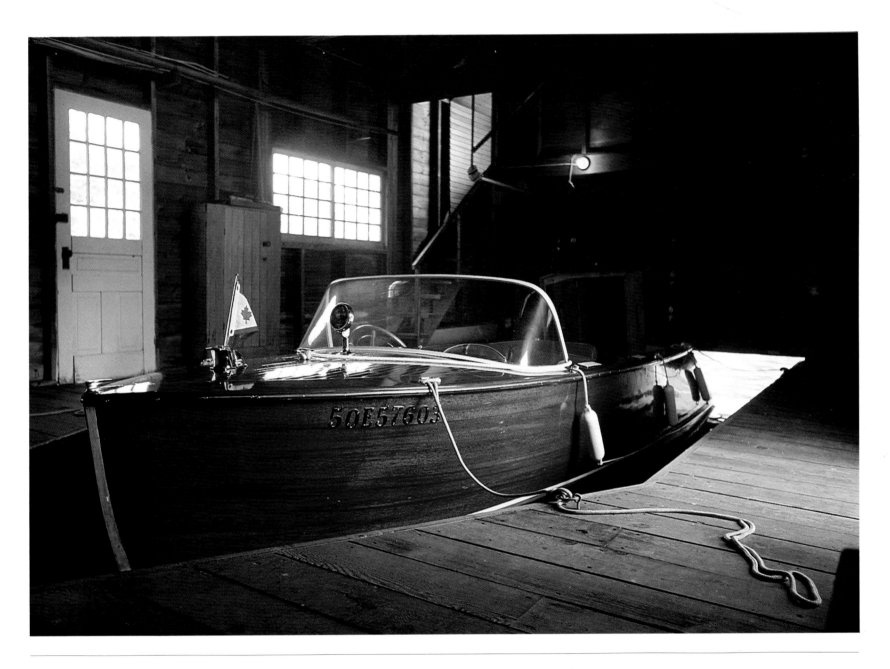

*Jomar*, one of the last Duke mahogany launches (built in 1966) occupies the downstairs of the smaller boathouse. Upstairs is a rustic sitting room and a tiny balcony with two Muskoka chairs. When Arthur Angus was a teenager, this was his favourite hideaway.

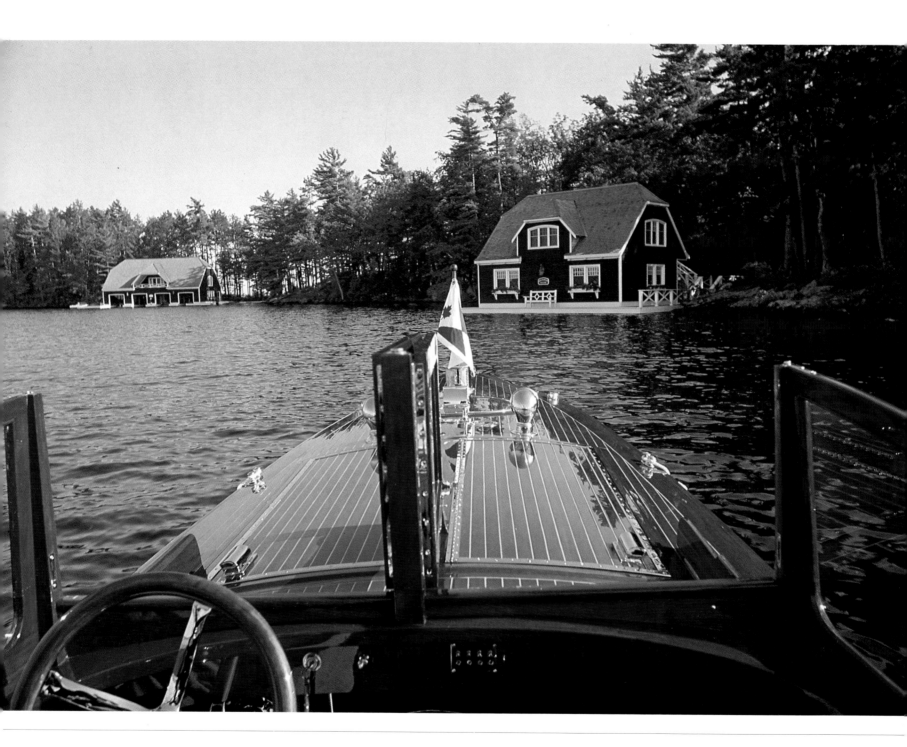

The two boathouses at Old Woman Island as
viewed from *Marie*, a 27-foot Minett launch.

# 3

# OLD WOMAN ISLAND

### L A K E   M U S K O K A

Several native myths have been told to explain the name of Old Woman Island on Lake Muskoka. The most enduring is that a native brave left his wife on the island in order to run off with a younger woman. The island was deserted until Richard Grand bought its 15 acres in 1987. There was nothing on it except neat circles of stones, firepits left by visitors who had used the island for cookouts and blueberry picking. Today the landscaped property has a newly built five-bedroom cottage and, at the water's edge, two boathouses that look as if they have been there forever.

"We wanted them to look like Old Muskoka in architectural style," says Richard, "and then we stained them charcoal-black to make them appear older." Richard, whose family has been summering in Muskoka for generations, lives in Ottawa with his wife, Karen. It was on their car journeys from Ottawa to Muskoka that they had the idea to use black stain instead of the more common grey, brown or green. "We saw black farmhouses in Simcoe County," says Karen, "and they looked so attractive that we decided to copy the idea." The painter who tackled

the four-month job lived on the island and worked every day. The finished result is a duo of handsome boathouses. Fine craftsmanship can be seen in details like the arched windows, the modified gambrel roof and the bevelled edges of the dock planks.

The larger boathouse was designed specially for Richard's collection of antique boats. Bobbing side by side in their berths, with their thick white ropes neatly coiled, are *Nozark*, a 21-foot 1924 Ditchburn; *Grand Old Lady*, a 26-foot 1949 Greavette streamliner; *Marie*, a 27-foot launch built by Bert Minett in 1917 (a true Minett," Richard says proudly); and *Ponder*, a 27-foot Ditchburn Viking with a stepped hull. The second storey is huge and "would make a great dance hall," but for now it has a large unfinished room and two bedrooms.

The smaller boathouse, with living quarters for Karen's parents, is decorated in summery colours. The compact space has a small kitchen, a bathroom and a cozy bed/sitting room that overlooks the lake. "It's an ideal getaway when my parents want to escape from the grandchildren," says Karen.

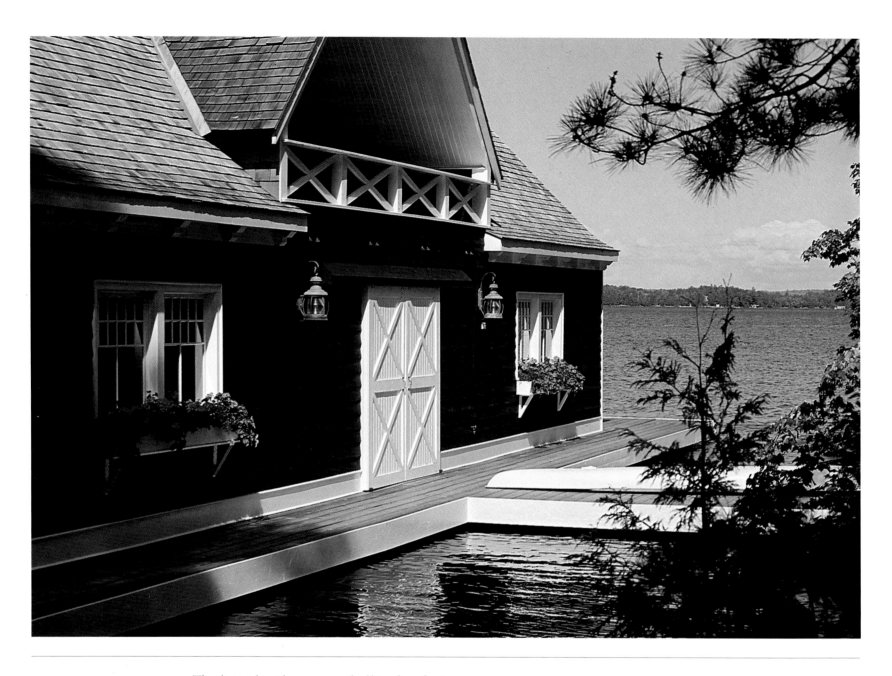

The large boathouse was built a few feet
offshore and two ramps connect it to
the island. The hanging lanterns
look suitably nautical.

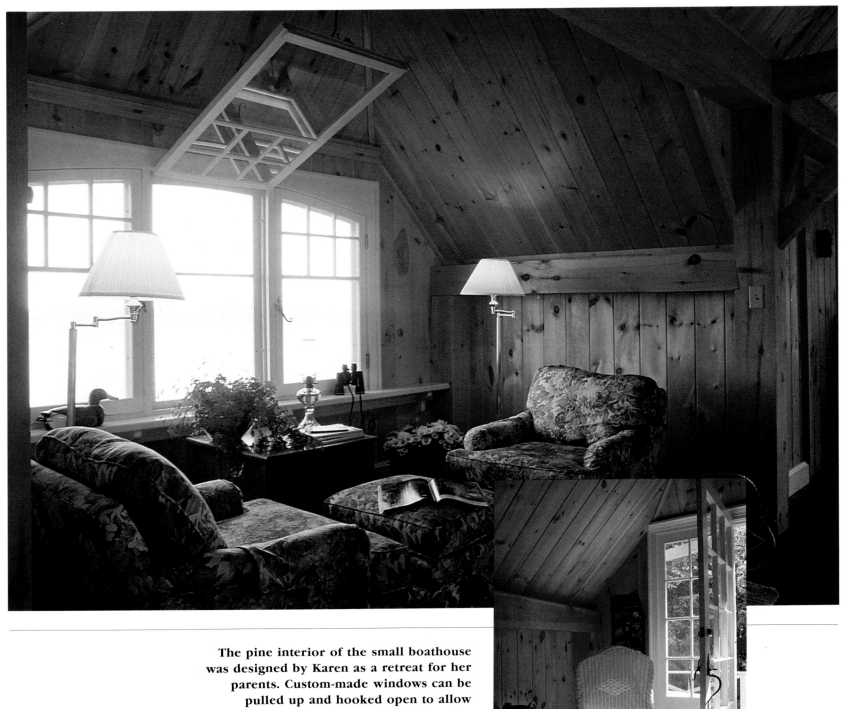

The pine interior of the small boathouse was designed by Karen as a retreat for her parents. Custom-made windows can be pulled up and hooked open to allow the lake breezes in.

AT RIGHT:

Sun streams in through the French doors, which have custom-made wrought-iron fittings. The floor planks are 12-inch-wide pine.

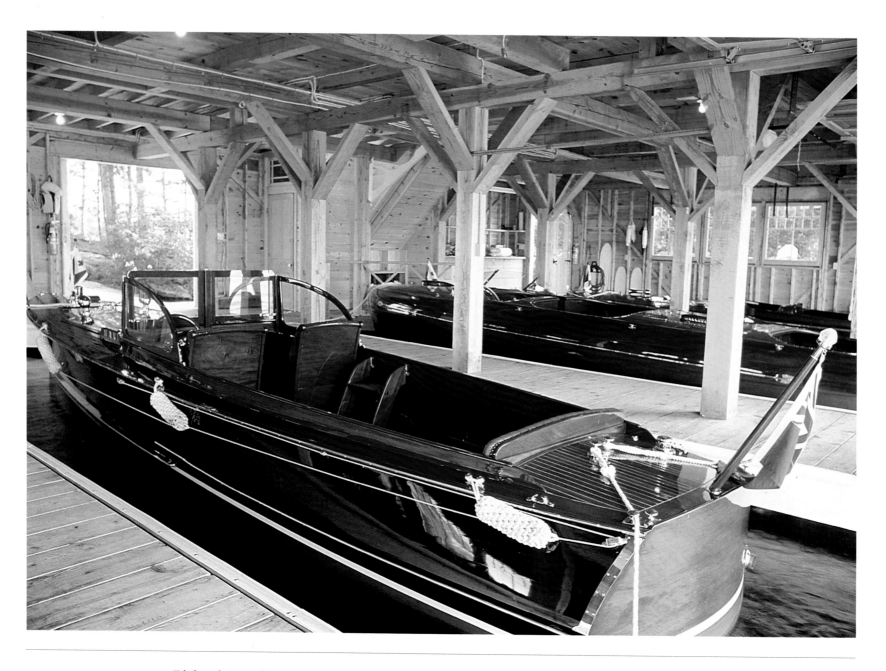

Richard Grand had the four-slip boathouse
designed specially to house his
collection of antique boats.

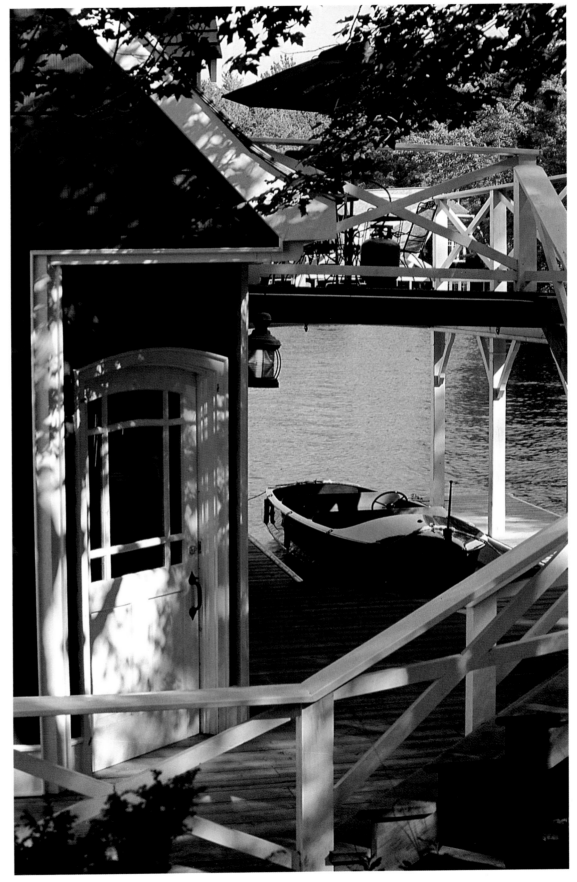

A 1939 Duke Playmate stored in the boat port of the small boathouse belongs to Karen's father and is known by the children as ''Bumpa's Boat.''

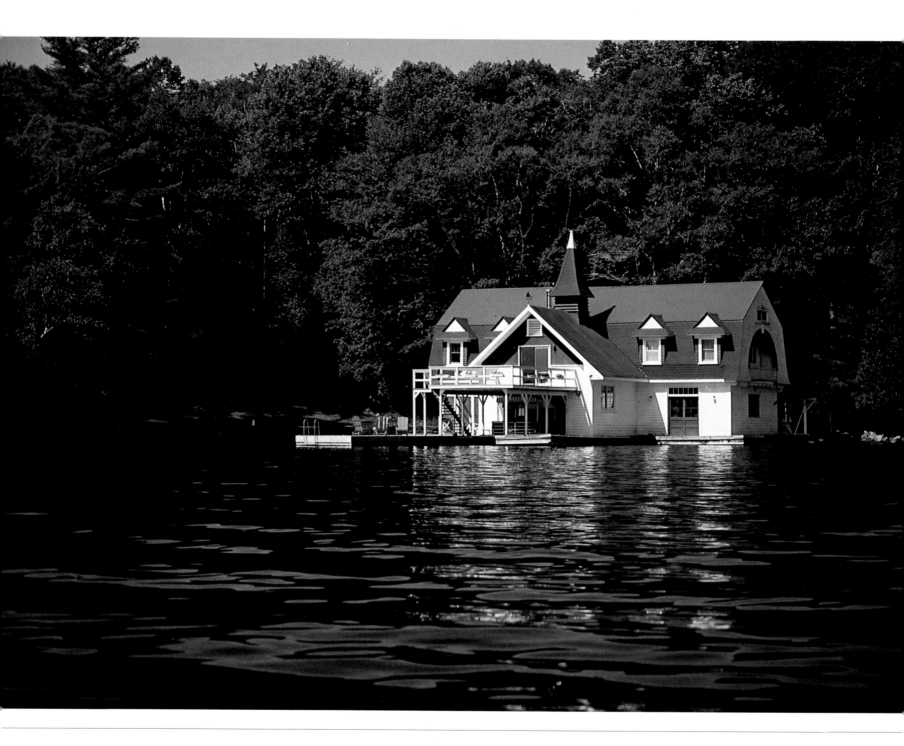

The boathouse now named Chadimar was built in 1903 by Toronto industrialist E.R. Wood. A cottage many times the boathouse's size but of similar style was built atop the hill at the same time. The gabled projection at the front of the boathouse was originally twice as long and was built to allow a 70-foot steam yacht to enter. Now there is a boat port for a pontoon and an upper-level sundeck.

# CHADIMAR

### L A K E   R O S S E A U

In the summer of 1903 the cocktail chatter on Lake Rosseau centred on the building of a cottage showplace on Mazengah Island. Neighbours around the lake watched with interest as Toronto industrialist E.R. Wood erected his hilltop summer mansion. He insisted on the finest of everything for the fourteen-room cottage and hired swarms of builders. He constructed an equally grand boathouse with the same barn roof, cupola and gables as the lavish cottage. Jutting from the front of the boathouse was a pitch-roofed boat slip, long and tall enough to house the 70-foot *Mildred*, his fabled forty-passenger steam yacht.

The property was bought in the early thirties by Mr. and Mrs. Charles Houson. They eventually passed it on to their only child, Marjorie, who married J.E. Frowde Seagram, of Seagram liquor fame. By this time the *Mildred* was long gone, and the Seagrams decided to alter the boathouse. The long, covered boat slip was divided in half and a floor added to increase upper-level living space. In the upstairs sitting room, you can still see the original fireproof tin ceiling. The outside deck and boat port are more recent additions.

Marjorie and J.E. Frowde Seagram raised their two children, Charles Geoffrey and Diane, here and named the cottage Chadimar, an acronym formed from the names *Cha*rles, *Di*ane and *Mar*jorie. The boathouse has three bedrooms, a living room with stone fireplace, a kitchen and the tin-roofed sitting room, which has a long banquet table for feeding large groups. Downstairs, the dry-slip area has been converted to a playroom. It has been painted in bold blue and white stripes and sports a mounted sailfish on one wall and cabinets full of board games. Today the cottage is owned by Dr. Geoffrey Seagram, and although his parents are no longer alive, their presence lives on. "Grandma came up here until her late eighties," says Geoffrey's daughter Kim, "and every afternoon her friends came for cocktails, clambering into the inclinater that would hoist them up the steep hill to the cottage." Grandma is most vividly remembered for her shocking pink, a colour that is found everywhere, on deck chairs, tables and towels. The Seagram daughters, Kim and Tracy, refer to it, with a slight roll of their eyes, as "Grandma's favourite colour."

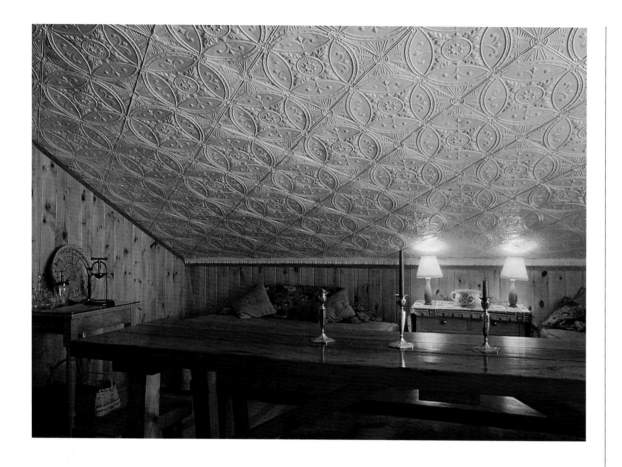

The fireproof tin ceiling was originally installed when this was a boat port for a steam yacht, the *Mildred*, sister ship to the *Rambler*, which still plies the Muskoka Lakes. In those days the boathouse roof had a chimney because the steam engines were fired up while the boat was still in its slip. The Seagrams had the tin ceiling sandblasted and repainted.

This room was built as a dry-slip area for storage but is now used as a party room.

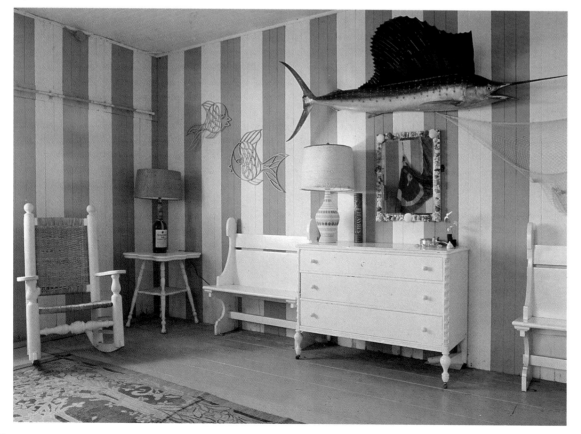

Guests first signed this wooden-covered guest book in 1946.

Eclectically furnished, the living room of Chadimar has sundry old pieces of pine and wicker mixed with 1960s rattan. In the background a small bat clings to the screen.

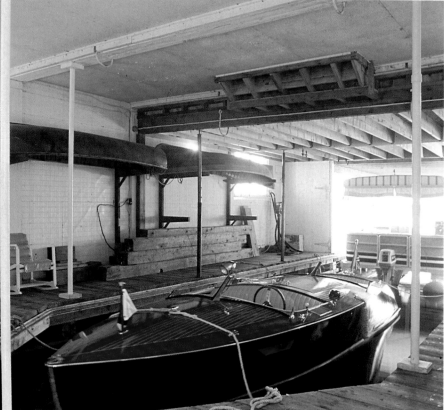

Tracy Seagram takes the inclinater up the steep hill from the boathouse to the cottage.

*The Gold Fawn*, a 21-foot Minett-Shields built in 1933, occupies some of the space formerly used by the *Mildred*.

The five changing rooms at dock level have been used by many generations. In one, there is a hole drilled in the rear wall. Now plugged by a cork, the hole was drilled from the workroom next door so that young Geoffrey Seagram could spy on the girls. Directly in front of the changing rooms are stairs leading into the water. These were originally built so that young women could slip into the lake without being seen in their bathing costumes.

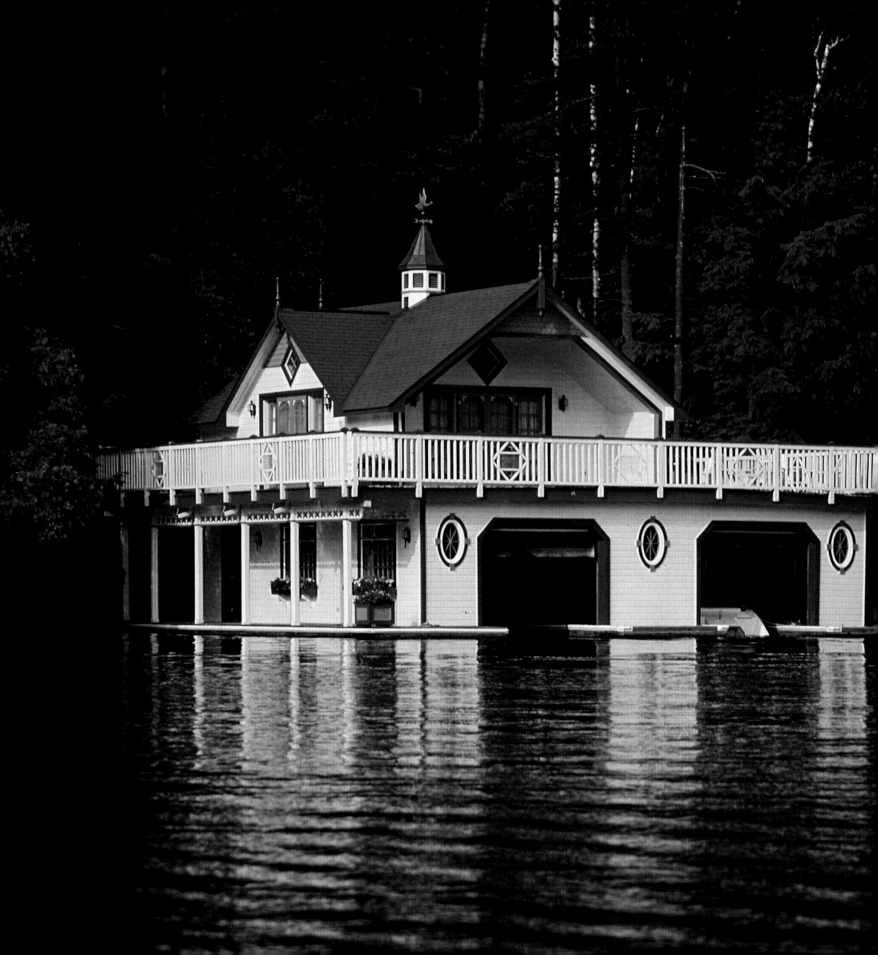

# THE PINES

LAKE MUSKOKA

Newly built but somewhat Edwardian in style, this fanciful boathouse on Lake Muskoka is in fact made up of an eclectic combination of architectural features. "The basic precept was that everything would look old," explains the builder, Bill Stokes, who designed the boathouse in co-operation with the owners, architecture enthusiasts who paid close attention to the finishing details. They travelled the Ontario countryside, taking photographs of favourite structures with interesting windows and unique trim and mouldings. They chose the colour scheme of yellow and green because it was popular when Muskoka cottages evolved from unfinished board-and-batten and were first painted. One of the owners also had a fondness for the colour combination because of childhood memories of a cottage north of Temagami.

The deep, gabled roof line and cupola were copied from an old boathouse on a nearby island called the Isle of Skye. Some of the wooden trim detail was inspired by Penryn Park, a Victorian Gothic mansion in Port Hope, Ontario. The railing design and oval windows are similar to the Cedar Island boathouse on Lake Rosseau. This combination of design influences blends together to create a handsome structure.

The boathouse sits at the base of a steep cliff. At the top of the cliff is a similarly styled two-storey cottage with a wonderful view of the north end of Lake Muskoka. Landscaped from top to bottom with tiered flower beds and a winding flagstone stairway, the property was named The Pines because of its rare stand of first-growth pine trees. The boathouse's interior, completed in 1991, consists of a spacious sitting room with an open kitchen and bathroom, a total of 650 square feet. Gingerbread-trimmed screen doors open onto the veranda on three sides. Diamond-shaped windows centred beneath the roof peaks draw attention to the unique herringbone ceiling design made of tongue-and-groove pine. "Even this ceiling pattern is a copy," admits Bill Stokes. "It's similar to the ceiling at Edenvale Inn, an old hotel in Port Carling."

A variety of windows add to this
boathouse's interesting appearance. The
multipaned windows on the boat-slip level
were copied from those in a vintage
Beaumaris boathouse. Three oval windows
across the front balance the boat doors.

A small but well-equipped kitchen allows guests to cook their own breakfasts.

Victorian-style screen doors lead from this cozy sitting room (used as guest quarters). The tongue-and-groove pine patterns on the walls and ceiling add to the room's appeal.

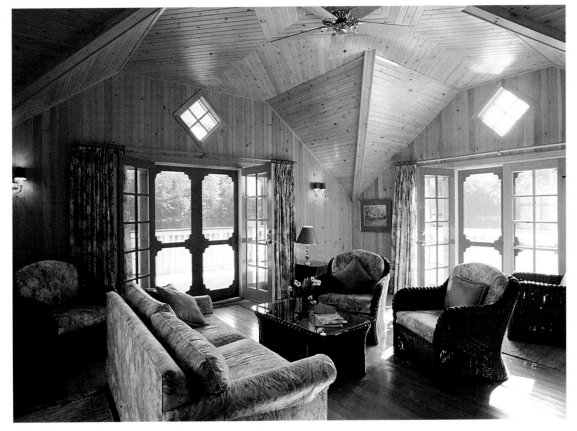

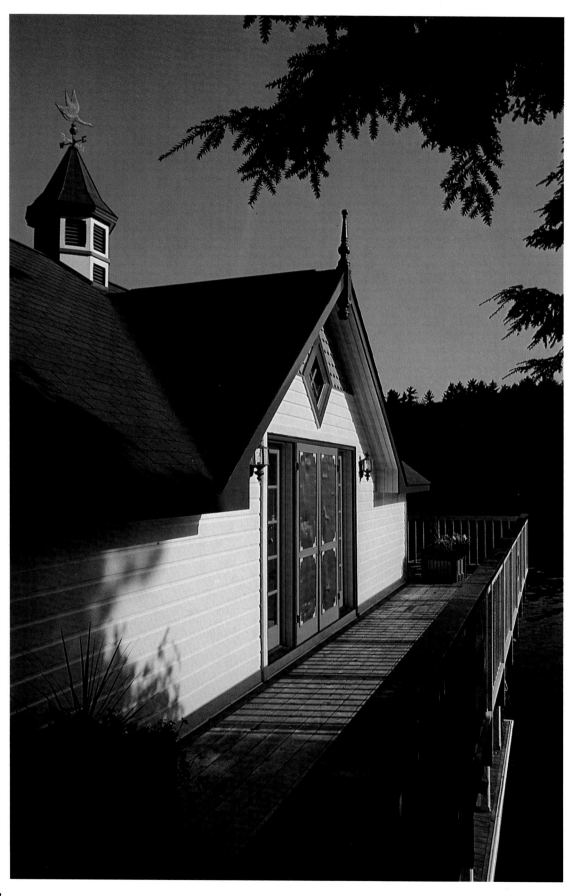

The fairy-tale appearance of this boathouse is due to such architectural whimsy as turned finials, chamfered spindles beneath the balustrade, an ornate cupola topped with a flying-goose weathervane, and plenty of ornamental bric-a-brac.

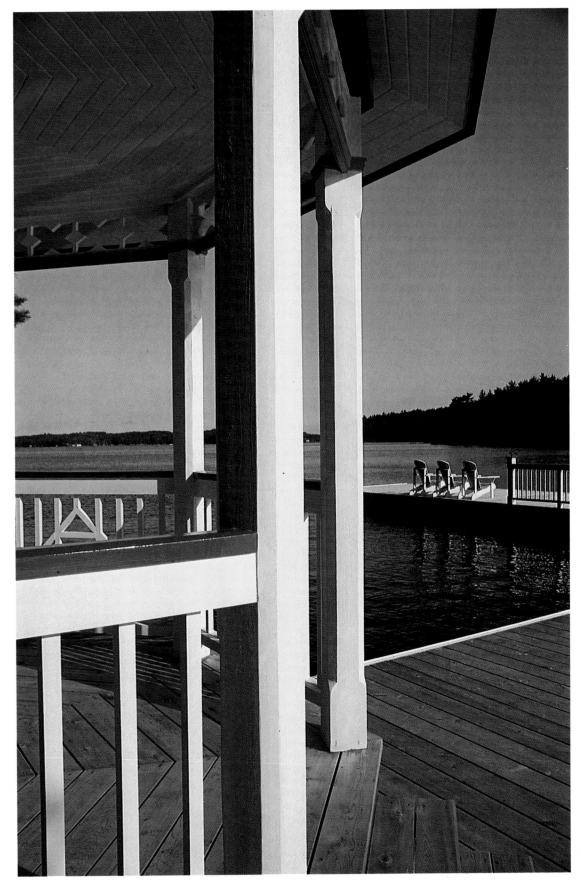

The gazebo built on the dock beside the boathouse has the same chamfered spindles, railing design and herringbone roof pattern as the boathouse. It faces west and is an ideal place to watch the sun set on Lake Muskoka.

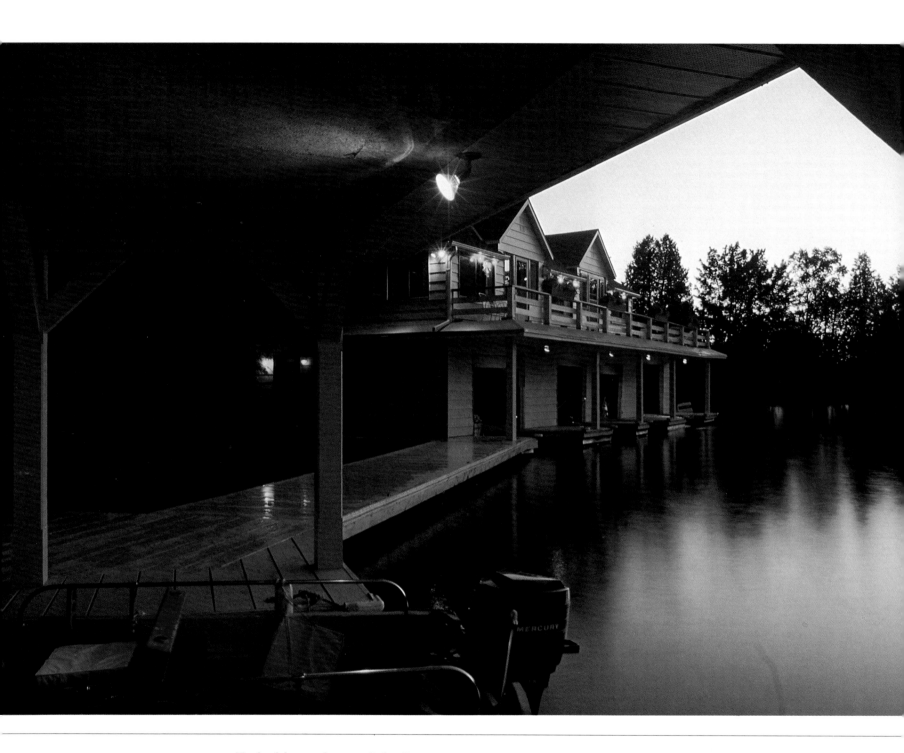

Tucked into a bay on Lake Rosseau,
this boathouse at Windy Ridge has been
enlarged twice over the years. Now with six
bedrooms, it is the summer home for a
family of four and shelter for several boats,
including two vintage mahogany launches.

# WINDY RIDGE

## L A K E   R O S S E A U

When Michael and Gwen Wilmott were married twenty-five years ago, they inherited this boathouse, part of a family compound on Lake Rosseau. Today, after being enlarged twice, it is the place they and their two children feel most at home, the place where they spend every summer. Michael's parents bought the property named Windy Ridge in the early 1950s. The original large cottage and various outbuildings were built in 1936 by Milton Cork, founder of the Loblaws grocery chain. Back then, the boathouse had just three slips and a small living quarters for the boatman that the family hired to take care of their mahogany launches.

Over the years there have been two major additions to the boathouse. About fifteen years ago the Wilmotts doubled the size of the living quarters, adding a fourth boat slip and a second gabled doorway on the east side of the building. A few years later, because, as Gwen Wilmott says, "The guests were sleeping in tents," they expanded again. This time they added a family room and two bedrooms, all three backing onto the land behind the west-side deck. Now it is a spacious, rambling summer home with six bedrooms, a living/dining room, kitchen, family room and two bathrooms.

The whole place is geared to summer living. Everyone in the sporty family of four prefers to be outside, and in good weather they practically live on the deck, where they eat breakfast, barbecue and relax with cocktails. "It's a bit of a roadhouse atmosphere," admits Gwen Wilmott. "We're close to the country club, so often the young people — our children and their friends — end up here instead of going home."

In decorating the interior, Gwen had just three goals: bright, cheerful and comfortable. Living on the water, she feels, has the psychological effect of making things more casual. At one point the family discussed getting rid of the picnic table that they use for indoor dining and replacing it with a more formal table and chairs, but somehow a regular dining table just didn't suit their Muskoka lifestyle. The picnic table remains.

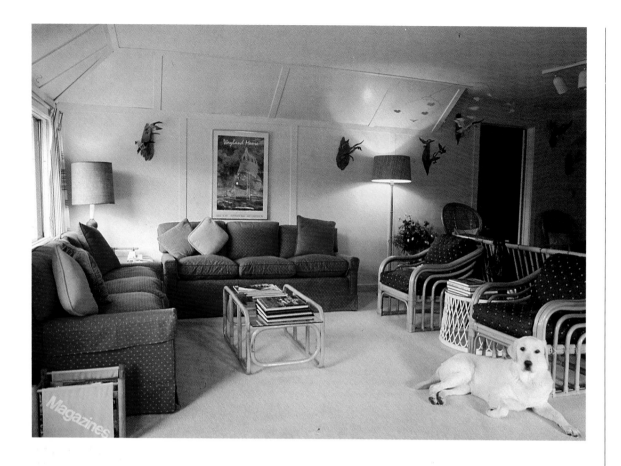

Jasmine, the family's golden Labrador, is at home in the boathouse's bright, cheery living room. Old wallboards, given a fresh coat of white paint, form the backdrop for a collection of handcarved birds by local artisans Walter and Beth Ruch.

A young girl's bedroom with view of trees and water.

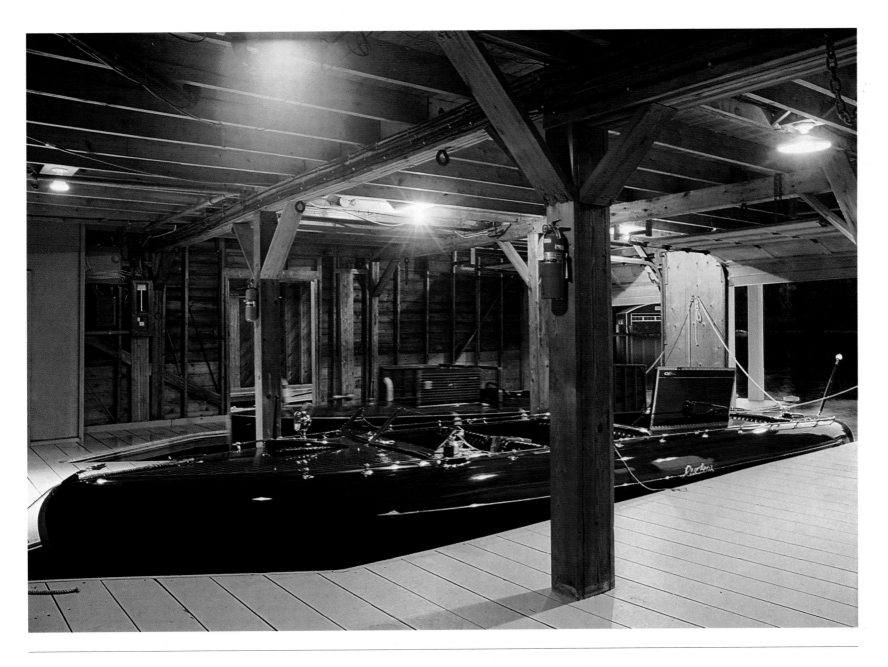

The family's two launches. *Curlew*, a 33-foot Greavette with a V-12 Scripps engine, was the fastest boat on the lakes back in the late 1930s. The *Pippit*, a 24-foot Ditchburn, was built in 1925.

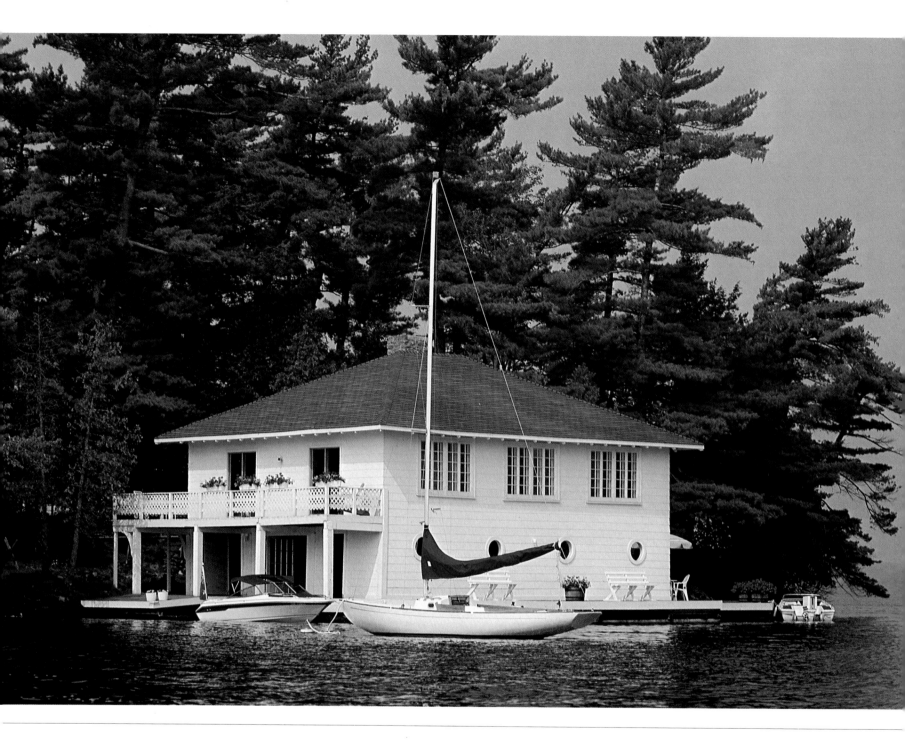

The unusual design of this two-slip boathouse
features a single-door entrance at opposite
ends and a dry-slip area, as well.

# SULLIVAN ISLAND

L A K E   J O S E P H

**P**roudly displayed on the cottage wall at Sullivan Island is a framed property deed. Tattered and yellowed, it is dated October 1900, when the property sold for $800. Like other cottagers, Laurence and Caroline Wight are fascinated by the history of their summer home. When they bought the island with its vintage cottage and boathouse in 1978, the contents were included — a windfall for these two avid collectors. Cupboards and drawers stuffed with linens and china, and rooms filled with antique wicker furniture, helped them unearth the cottage's past.

Their collections, in both cottage and boathouse, continue to grow: hutches full of tinware, shelves stacked with cut-glass carafes, walls lined with cast-iron grates, and perhaps most fascinating of all, a collection of stuffed birds. "We got to know a taxidermist who did birds," explains Laurence, "and we particularly liked his choice of mounting materials, all very natural-looking pieces of driftwood or rail fence." Upon entering the sitting room of the boathouse, one is greeted by a large white swan, a flying mallard, a barn owl and a great blue heron.

The white two-storey boathouse, still clad in its original set of asbestos shingles, is nestled in the leeward side of the island. The two boat slips house a sleek Canadian-built Kavalk and a fourteen-year-old Century launch. Everything is shipshape. For people who never throw anything out, the Wights manage to keep things in amazing order. And artfully arranged. Hanging above the boats, for example, is a neat line of old boat pennants. Rather than toss them out when they get faded and frayed, the Wights hang them from the overhead beams. Upstairs, the boathouse has a large, sunny sitting room with a Muskoka-stone fireplace, three airy bedrooms and a bathroom. The Wights painted the wicker glossy white and removed old varnish from tables and dressers. They lightened the basswood walls with a semi-transparent white stain and sanded the pine floors, which they plan to stencil. The comfortable space, used mainly by weekend guests, has the serene atmosphere of an earlier time. And, as is often the case in collectors' homes, in every corner there is something for the eye to linger over.

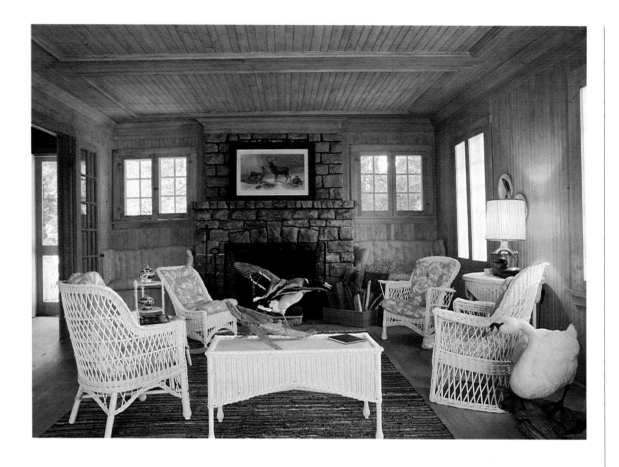

Stuffed birds occupy corners of the vast sitting room. The Wights painted all the old wicker white and chose bright yellow cotton for the cushions and the built-in window seats beside the stone fireplace. Six pairs of curtainless casement windows surround the room, allowing plenty of light to filter in, and the basswood has been lightened with a translucent white stain.

The bedrooms are spare and evoke another era. The furniture all came with the cottage, some of it already had handpainted designs done by its American former owners. All three bedrooms have huge closets designed for the steamer trunks that were rolled into them in the days when cottagers arrived by steamboat and stayed for the summer.

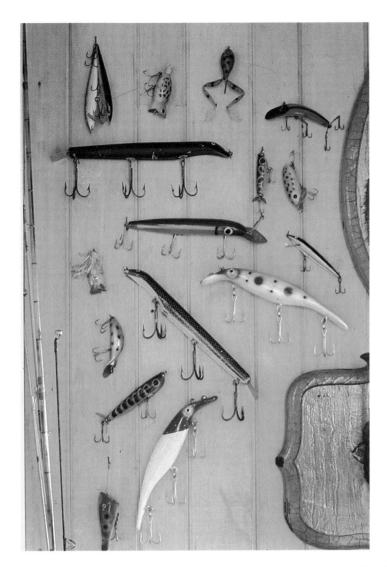

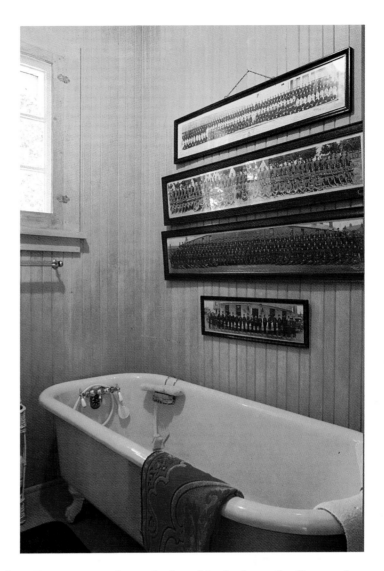

The Wights have a knack for turning clutter into artistic displays. Every corner has a designed look, from the firewood gathered in a wicker basket (with chewed beaver sticks in among the odd pieces of lumber), to pine-cone arrangements, to walls covered with fishing lures. "You never have to bathe alone," says Laurence Wight of the whimsical boathouse bathroom where walls are filled with panoramic group shots. Included on the wall of sepia photographs are army divisions from World War I, hospital staff, and a group shot of Ontario Provincial Police at Kitchener.

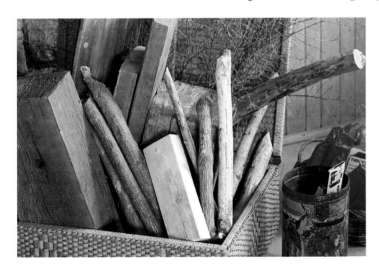

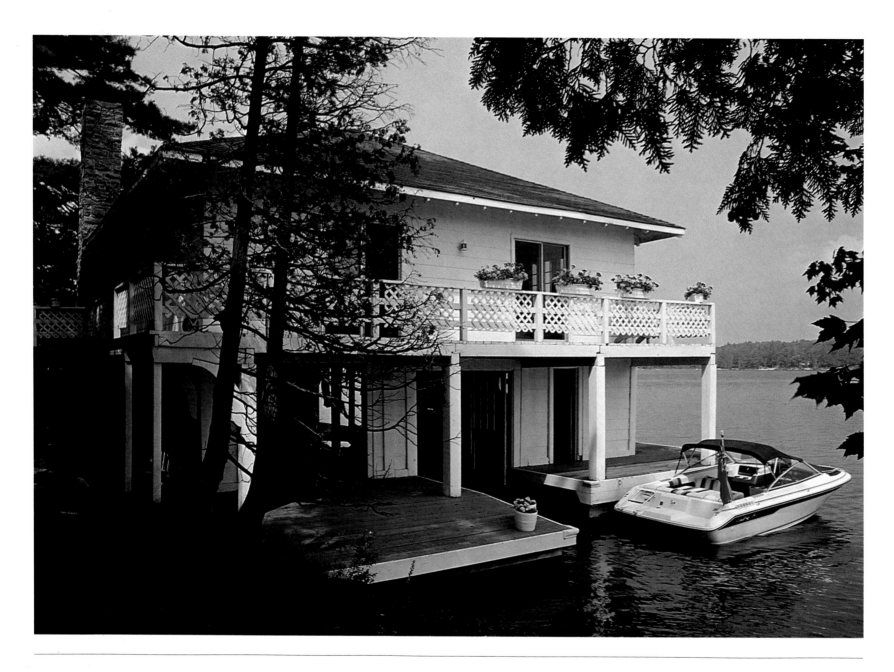

The circa 1900 boathouse was originally
board-and-batten, which was later covered
with asbestos shingles. "Not my choice,"
says Laurence Wight, "but they're fireproof
and amazingly durable. We just keep painting
them over and over." Sometime in the early
seventies, sliding glass doors were put in
the two bedrooms as walk-outs to the balcony.

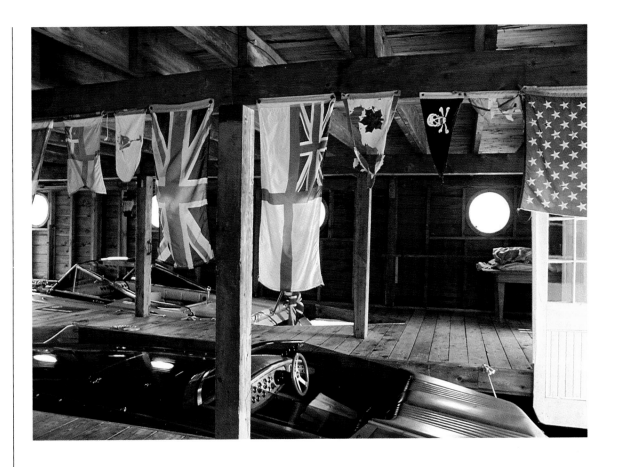

The Kavalk is a 1986 Canadian-built gentleman's racer designed to resemble the Italian Riva speedboats.

A place for everything and everything in its place.

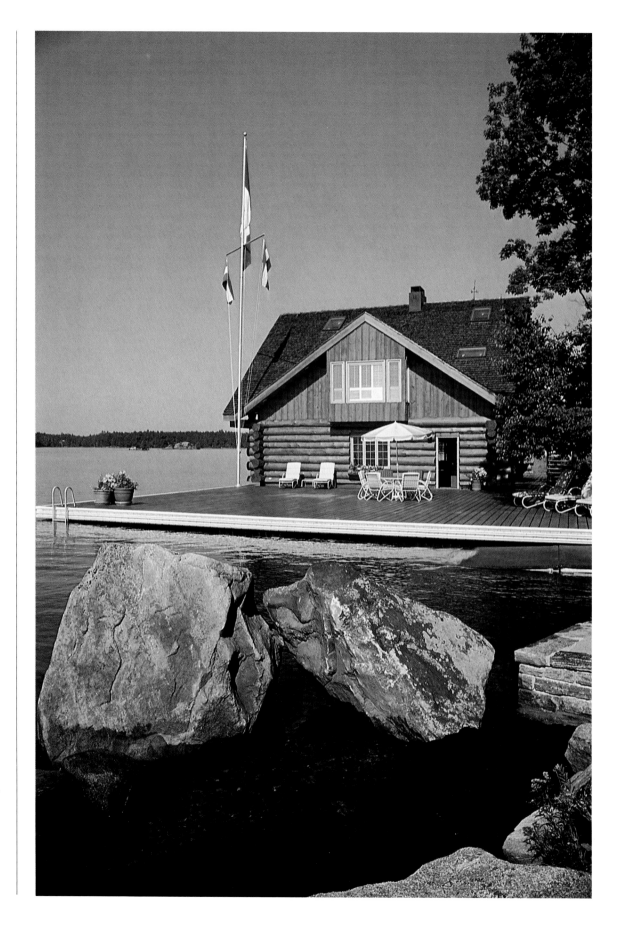

The lower half of this log boathouse was constructed of thick pine logs, some of them 50 feet long and almost 2 feet in diameter. The notched logs, piled one on top of the other, have no chinking and rely on the weight of the upper building to hold them in place. The upper storey, with its three steep gables, is a 2,000-square-foot living space used as year-round guest quarters.

# MONTCALM POINT

L A K E  M U S K O K A

This property is a sweeping headland that was once owned by a French-Canadian hotelkeeper back in 1900. He built a small resort and named it after his idol, French General Montcalm, who died fighting for New France. Montcalm House operated as a resort until 1942, when, like so many Muskoka hotels, it burned to the ground.

On the same height of land where the hotel once stood, current owners Patrick and Michele Brigham built their glamorous log-and-stone cottage. The boathouse, made from the same hefty pine logs, was constructed in two phases. The lower level, with three slips for boat storage, was built in 1986. Three years later a second level was added, with 2,000 square feet of living space designed as a luxurious winterized guest cottage. "This was an interesting project," claims Ernie Taylor, who collaborated with a log builder in the construction of the Brigham boathouse. "It's the only round log boathouse in Muskoka that I know of." The building process began in the winter, when a dozen 6-foot-by-12-foot cribs were sunk through the ice and filled with stone. "We laid the cedar decking after the spring break-up," explains Taylor, "and then the logs arrived, all pre-cut, tagged and notched to fit. They were assembled using a crane right on the site."

The logs are green at the time of construction, and they dry and shrink over a period of five years. Allowance must be made for this shrinkage around windows and doors. Because moisture was emitted by the logs while they were curing, the Brighams air-conditioned their living quarters. Guests visiting the Brigham boathouse find not only air-conditioning, but other amenities rivalling those of a five-star hotel. The decor is opulent, the lake views unparalleled, and the closets hold terry robes. Two lavish bedroom suites, each with an adjoining bathroom, feature bay windows and walk-outs to the balcony. Sunlight slants in through the white louvered shutters, and fans spin slowly overhead, giving the rooms a California ambience. The main living area has a cathedral ceiling and plenty of natural light from ceiling-high windows and skylights. Dominating the room is a 25-foot copper fireplace with a hearth of green slate. This fireplace opens into both the kitchen and living room. In the daytime, sunlight bounces off the fireplace's shiny copper, and at night tiny halogen spotlights beam down from the ceiling. "I wanted to create a romantic atmosphere in this boathouse," claims Michele Brigham, "so the feeling in this room is just like being outside on a starry night."

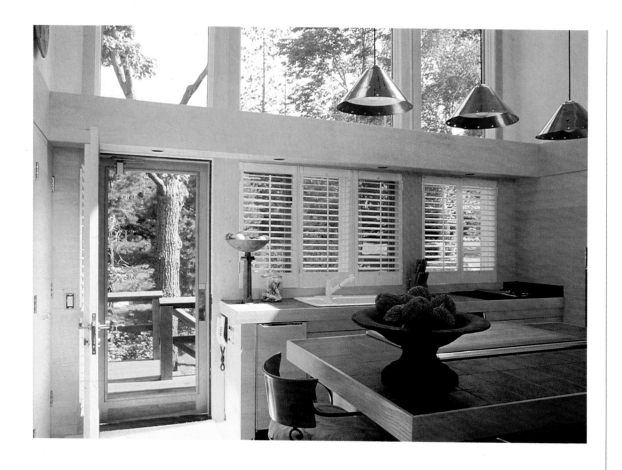

The kitchen's centre island has a built-in Japanese grill, a trio of copper-shaded lights, and cushioned metal stools.

A California flavour permeates the two guest bedrooms. Bleached oak trim, brass beds, potted palms and white louvered shutters create a sun-soaked atmosphere.

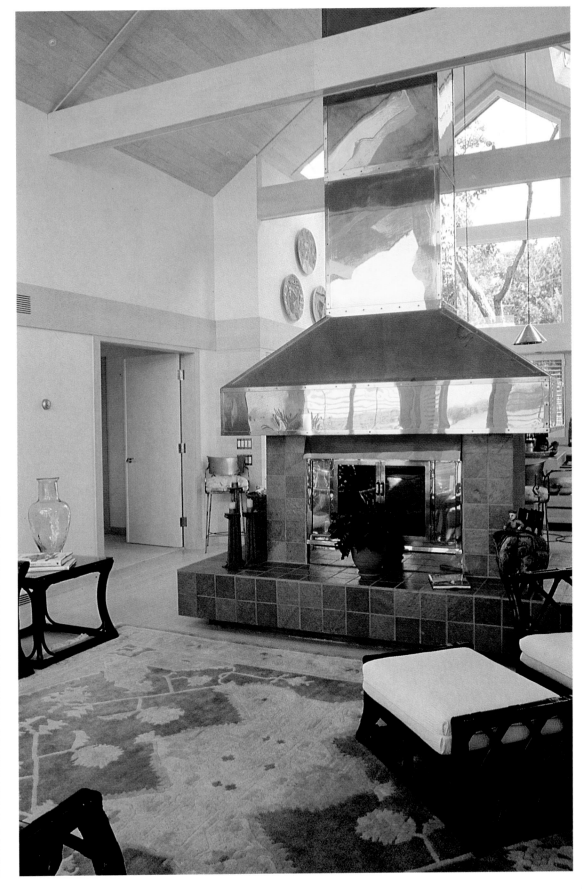

The freestanding zero-clearance fireplace has a copper chimney that rises 25 feet to the peak of the roof. The green slate on the hearth is repeated in the kitchen and bathrooms, and both the floor and ceiling of the living room are bleached oak.

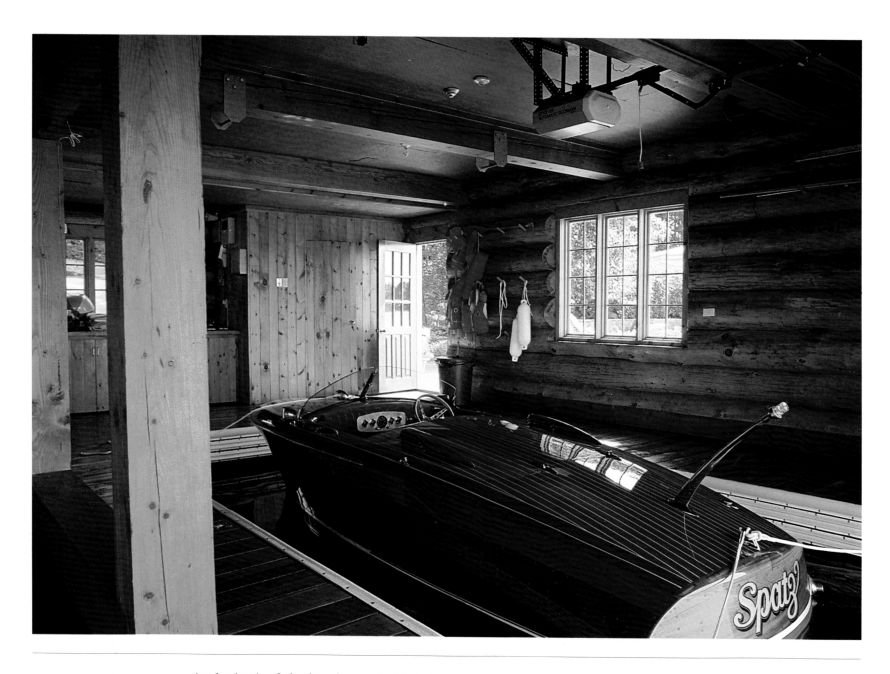

At the back of the boathouse, behind the
slip housing *Spatz*, the Brighams' 12-foot
Sheppard roadster, built in 1943, there is a
two-piece washroom and a built-in bar.

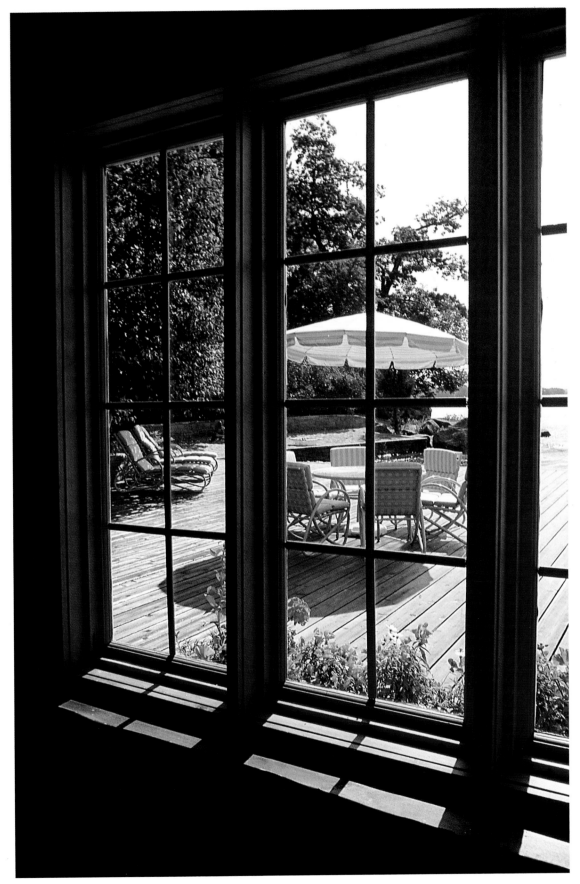

Seen here from inside the boathouse, a large cedar deck wraps around the shoreline. The flowers seen through the glass are in window boxes made from hollowed-out logs.

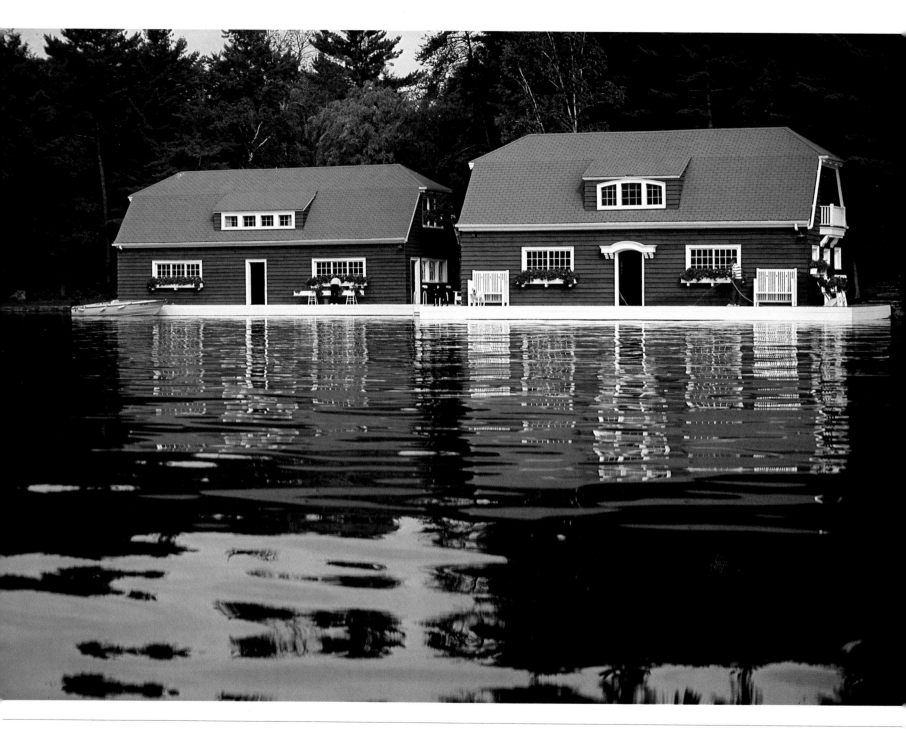

The Boys' (right) and Girls' Boathouses at
Gibraltar Island were built at the entrance
to a protected bay, with a crescent of
beach and calm, shallow water.

# GIBRALTAR ISLAND

LAKE MUSKOKA

The original owners of this rocky point on Gibraltar Island in Lake Muskoka were actors who toured Muskoka theatres at the turn of the century. They built a small cabin on a crest of land facing east towards Beaumaris. A grand two-storey brown frame cottage now occupies the same site. Down at the water's edge are two look-alike boathouses. In 1913, after the theatre folk had moved on, John H. Hillman of Pittsburgh bought the property and built the existing cottage and boathouses. Hillman, his wife and their seven children summered here for many years. Today the property is owned by grandson Henry L. Hillman Jr. and his wife, Kiki, of Portland, Oregon.

The Hillman boathouses resonate with family memories. One boathouse is called the Boys' Boathouse, as the male children slept in its large, open dormitory. Just off the balcony is a secret door known as a Lindbergh door because of its popularity following the kidnapping of Charles and Anne Lindbergh's son. These hidden doors locked from the inside and were built to allow children to escape. The other boathouse is called the Girls' Boathouse. It is a more private, feminine suite with a sitting room and separate bedrooms. Both the cottage and the boathouses were designed by Brendan Smith, a Pittsburgh architect who was hired to design several of the American summer homes in the Beaumaris area. One of the striking differences in the two boathouses is the step-out Juliet balconies at either end of the Boys' Boathouse. "It's still a mystery in our family," says Henry Hillman Jr. "In the original photographs, the Girls' Boathouse had balconies. We wonder if there was a fire at some time and it had to be rebuilt. But we have no record of it."

There's no shortage of boats to fill the slips. In the double boat slip of the Girls' Boathouse is the dazzling *Silver King*, a Gold Cup racer originally built for the Ringling Brothers in 1927. Propped up on stilts at the end of the slip is another prized craft, the *Walnut Diamond*, a wonderful rowing boat built around 1915 that Henry claims "skims across the water like a feather." The deep double slips in the Boys' Boathouse shelter four mahogany boats. Upstairs, where the boys spent many rough-and-tumble nights as children, Henry now has an office. He comes to this quiet place to read and work and no doubt think back to his childhood summers in this very same boathouse.

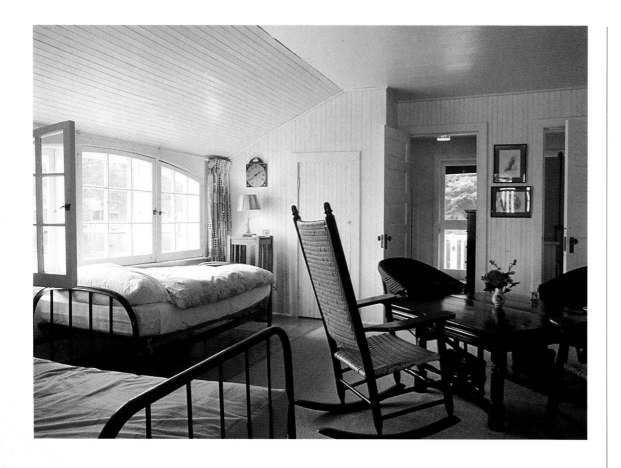

The large dormitory room in the Boys' Boathouse hasn't changed in years. Old hospital beds have been used by several generations of young Hillman boys. The same furniture was here when its owner, Henry Hillman Jr., was a boy. He now uses it as an office.

The bedrooms in the Girls' Boathouse are private, small and simply decorated. When built in 1913, the bedrooms were for the nannies and servants. Furniture in these old island boathouses rarely changes, because it is so difficult to haul away.

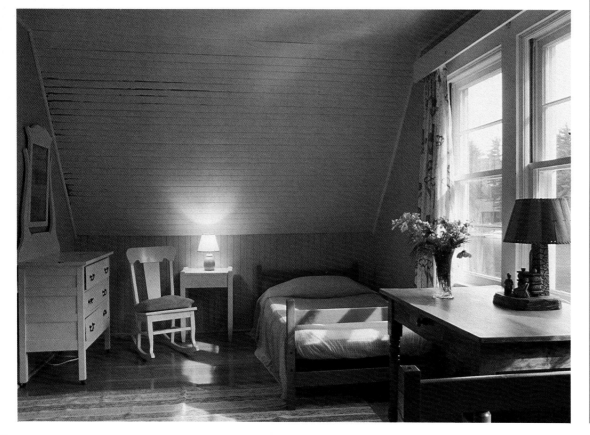

**OVERLEAF:**
Every year the family has a 10-inch sailboat race, and all the boats must be handmade. The "Christmas Island 10-inch Sailboat Regatta" is a treasured family event for both adults and children. "Everyone gets in the water with their boats," says Henry Hillman Jr., "and there's always lots of cheating."

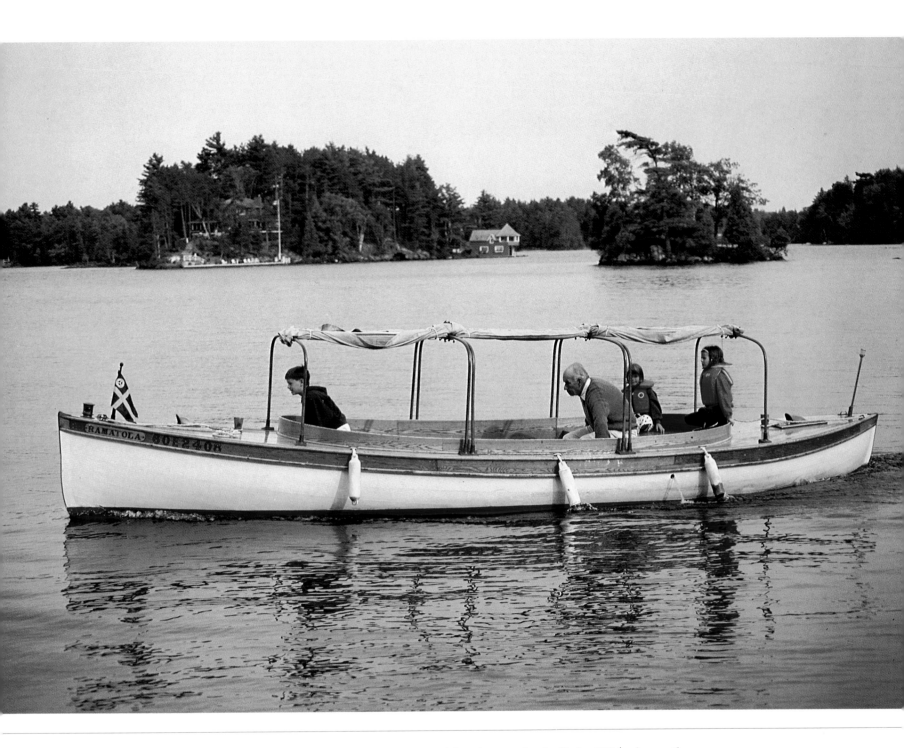

The *Ramatola*, built in 1904, drops the grandchildren off for a visit. It is owned by Tom Hilliard, a relative of the Hillmans whose summer cottage is nearby.

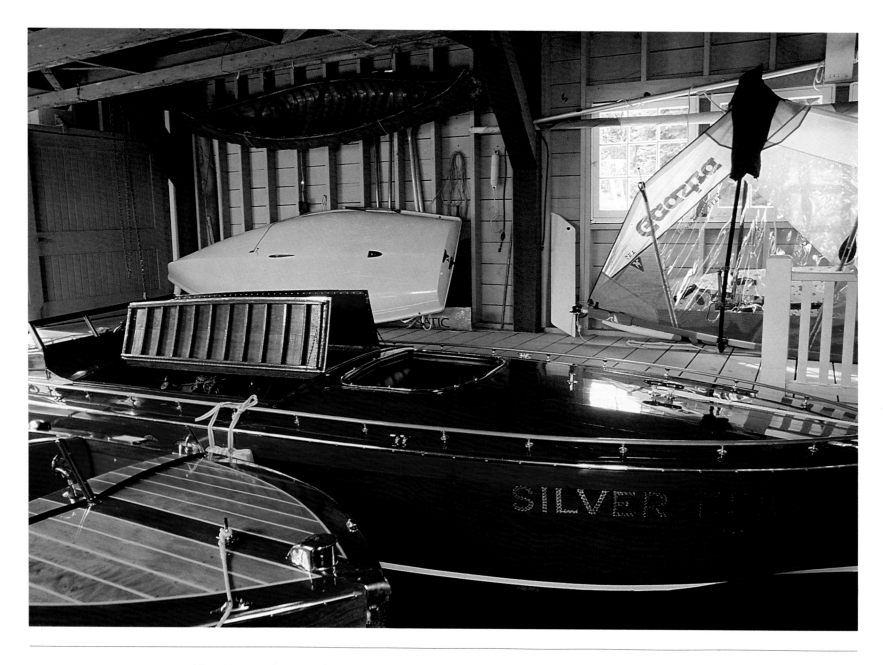

The *Silver King* was built as a Gold Cup racer just before the stock market crash of 1929. As a result, it never raced. The boat was restored in 1936 after sitting in dry dock for seven years.

Curved ornamental lintels grace the doorway of the Boys' Boathouse. The more spartan doorway of the Girls' Boathouse can be seen through the door.

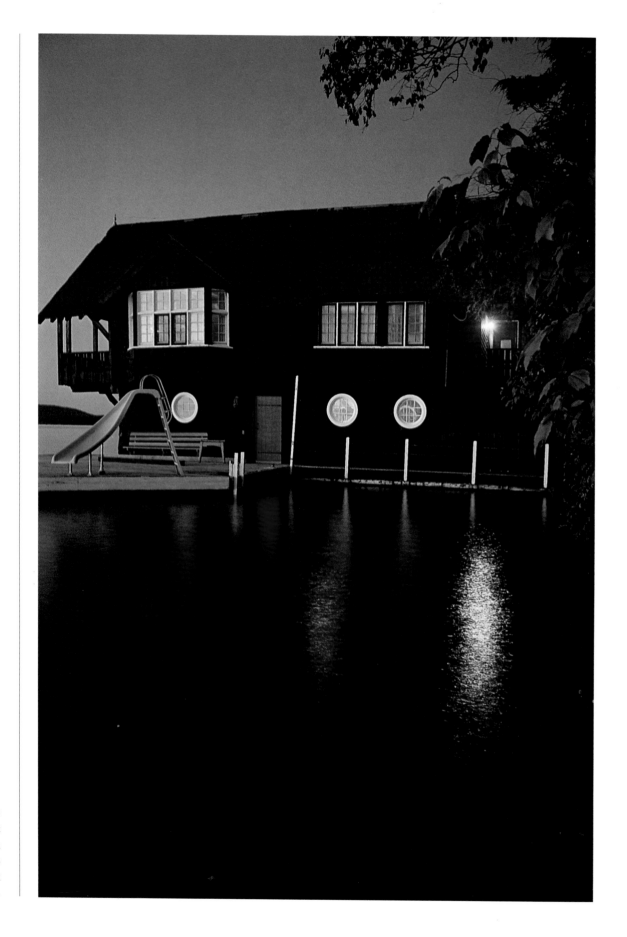

There is a generous dock complete with water slide for the children at this Lake of Bays boathouse, built in 1926. The covered veranda overlooks what remains of Bigwin Inn on the island across the bay.

# THE BOATHOUSE

LAKE OF BAYS

In the days when Bigwin Inn was the glamorous hub of social activity on Lake of Bays, this boathouse was a busy place, famed for its parties. It sits on the mainland, directly across from the renowned Bigwin resort, and its location was no accident. The cottage and boathouse were built in 1926 by Gordon Finch, who made a fortune in mining and wanted to own the largest boathouse on Lake of Bays. He chose this location so he could follow the action at Bigwin Inn just by sitting on his boathouse balcony, telescope at hand. To keep in touch, he installed a direct telephone line to the resort, connected by underground cable.

No expense was spared in construction. Finch imported British Columbia cedar for the boathouse's exterior, Douglas fir for its interior walls and ceilings, and installed a large stone fireplace in its living-room. Because he was an avid sailor, he added nautical flavour to the decor. In the centre of the living-room floor is a compass fashioned from inlaid coloured tiles. On the walls are maps, mariners' charts and model schooners.

The porthole windows are still intact, and there has always been a green door on one side of the boathouse and a red door on the other.

When John and Helen Scott bought the boathouse in 1949, they hardly changed a thing. "It's pretty much the way it always was," says Helen Scott. "Maybe there are some curtains that weren't always here. We regard this boathouse as a place to enjoy." As a young couple, they found the boathouse just as conducive to good times as did its former owners. Helen's children remember their parents' crowded parties when their father would stand by the fireplace and never move. Years later he confessed, "I thought the fireplace would be the only thing left standing when the boathouse fell in." Three Scott family weddings have been held in the boathouse over the years, including that of Helen Scott's granddaughter Lindsey Connell, who was married here at Thanksgiving in 1991. Even though Bigwin Inn now sits vacant and sadly neglected across the lake, the Scott boathouse remains a lively place, well used by family and friends all summer long.

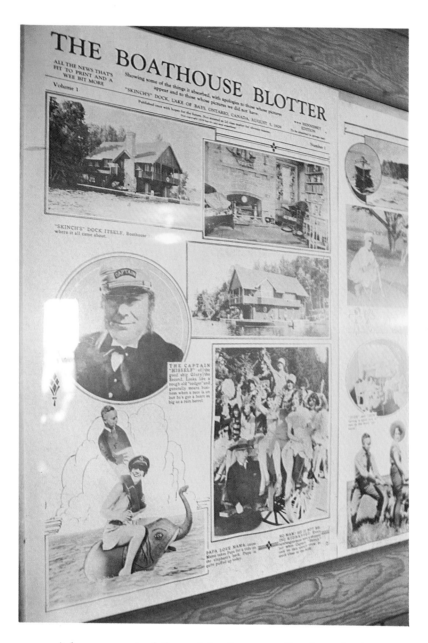

A houseguest of the original owner, Gordon Finch, a.k.a. Captain "Skinch" Finch, had this poster made for one of Finch's famous parties. The mock newspaper page portrays the antics of the boathouse owner and his friends.

The interior walls and ceilings are lined with Douglas fir imported from British Columbia.

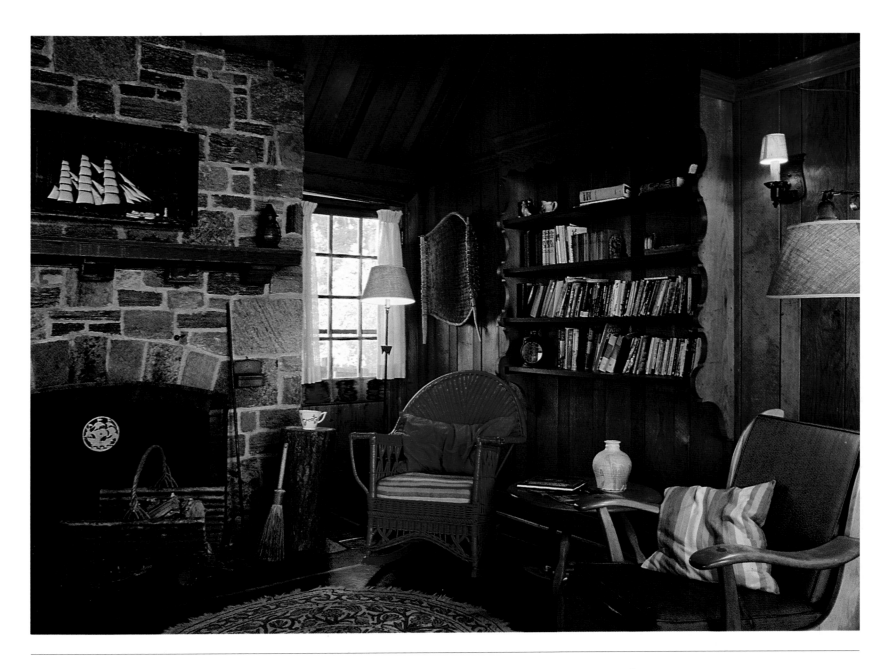

The large stone fireplace can be seen on the outside wall. "I sometimes think this fireplace is holding the whole place together," says owner Helen Scott.

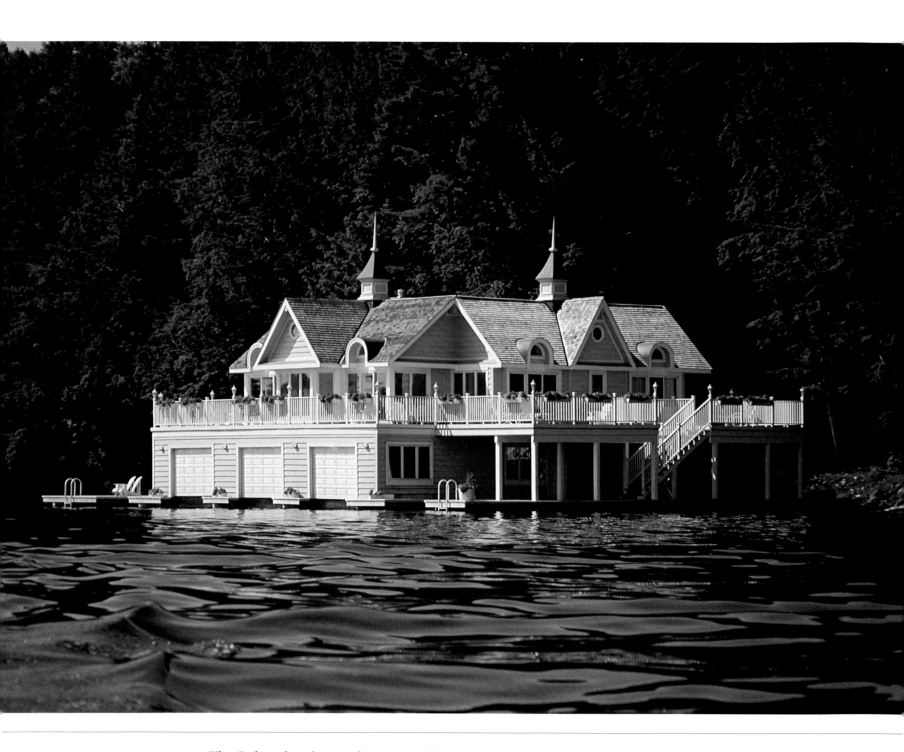

The Deluce boathouse sits on a pristine
section of Lake Rosseau shoreline. With
three boat slips and two covered boat ports,
there is plenty of space for boats. Along
one side is a specially designed dock for
Bob Deluce's Cessna 185 float plane.

# DRIFTWOOD

LAKE ROSSEAU

When Bob and Catherine Deluce built this boat-house in 1988, they intended to build a cottage as well, knowing that a two-bedroom boathouse would be too small for their family of six. But after a summer in this bright, sun-washed place, they loved it so much that they still haven't built the cottage. The four children settled into the lower-level bedroom, which has bunk beds to sleep six. The main living space is spacious and airy, with six sliding glass doors that lead to a wraparound deck. With the help of designer Kate Zeidler, the Deluces have created a summer house of elegant simplicity.

"We wanted the feeling of being at the seaside, where the light is so bright that everything looks a little washed out," says Catherine. On the outside, the boathouse is beached-driftwood grey, and inside, the palette of pink, mauve and blue is reminiscent of a summer sunrise. The printed fabrics were specially chosen to improve as they fade. "Only certain prints fade well," adds Catherine, "and we didn't use any solid colours."

In keeping with the simple summery look of the boat-house, the pine V-joint walls were stained translucent white to let the knots show through. The pine floors were washed with a non-yellowing white stain. A design of swags and flowers was handpainted on the floors in the same colour scheme. In fact, there is barely a thing in this boathouse that isn't pink, white, blue or mauve. Even the open-plan kitchen has rose-pink and periwinkle-blue tiles. And the newly installed zero-clearance fireplace has blue and white tiles on the surround and the hearth.

From the water the boat-house has a commanding presence, with distinctive trim details and many window shapes — trademarks of architect Tony Marsh. It resembles the grey-shingled seaside houses built along the New England coast in the late 1800s. But here the backdrop is thickly wooded shoreline and, out front, a sparkling northeast view of Lake Rosseau. "The tall trees on the shoreline cast long shadows at certain times of day," explains Marsh, "so we positioned the boathouse and the decks to receive the maximum amount of sunlight."

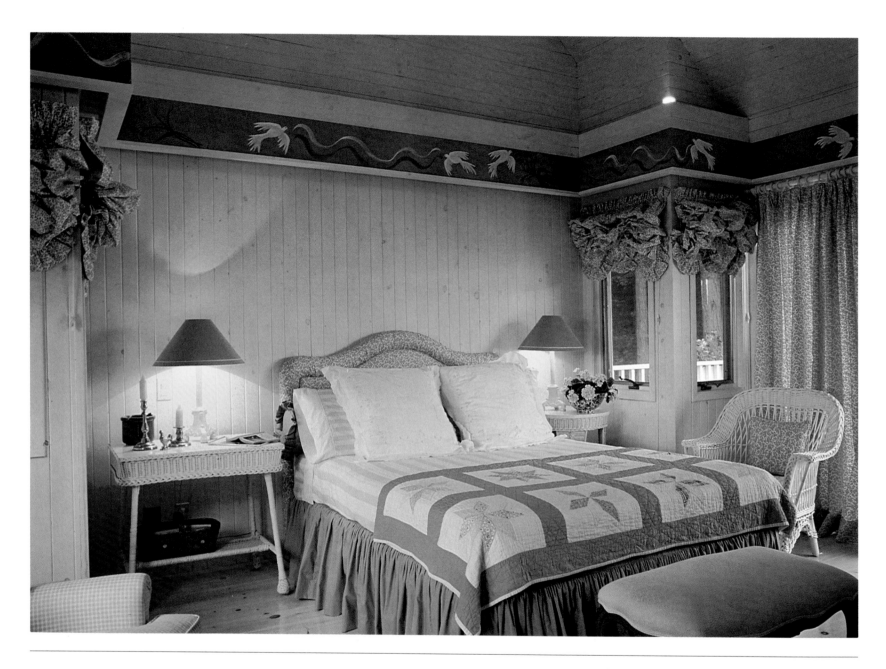

A painted "peace dove" frieze by Stacey
Lancaster surrounds the master bedroom.
On the bed is a vintage Lone Star quilt in
all the right colours. The bedroom has
windows with lake views on two sides.

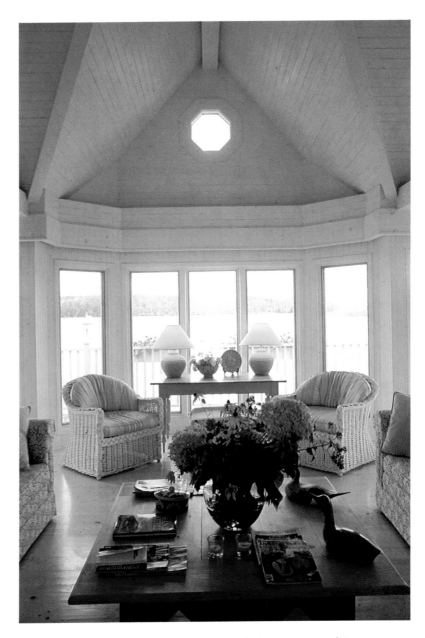

Inside the sun-washed boathouse is a large open space with a living room at one end and a kitchen and dining area at the other. The extra-long sofas are covered in a blue-and-white cotton print chosen to fade nicely in the bright light.

The beams and arches are all stained the same translucent white as the walls. None of the windows or sliding doors are covered, so when daylight pours in, the boathouse feels like a seaside cottage.

Toronto artist Stacey Lancaster handpainted the floors, which were first given a coat of non-yellowing white stain. The milk-painted dry sink was also washed with a white stain to soften the blue and make it look a little more worn.

Catherine Deluce painted an antique brass baker's rack in white enamel and then filled it with favourite pieces of blue-and-white pottery.

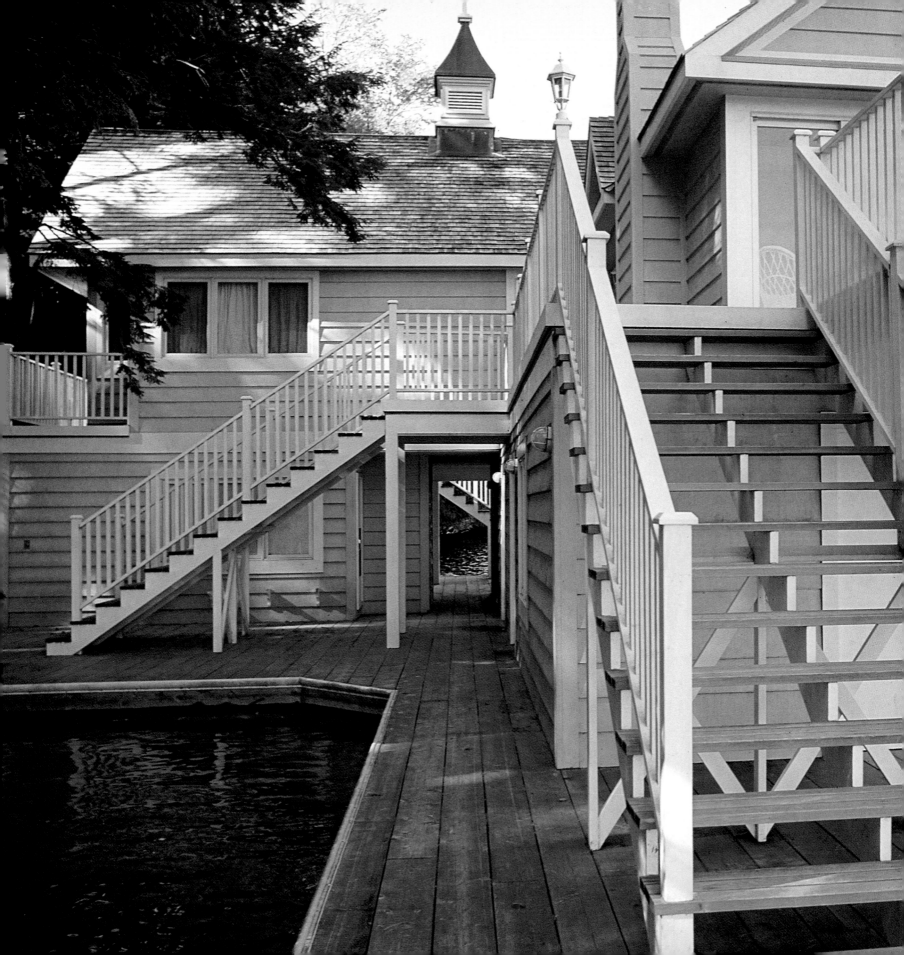

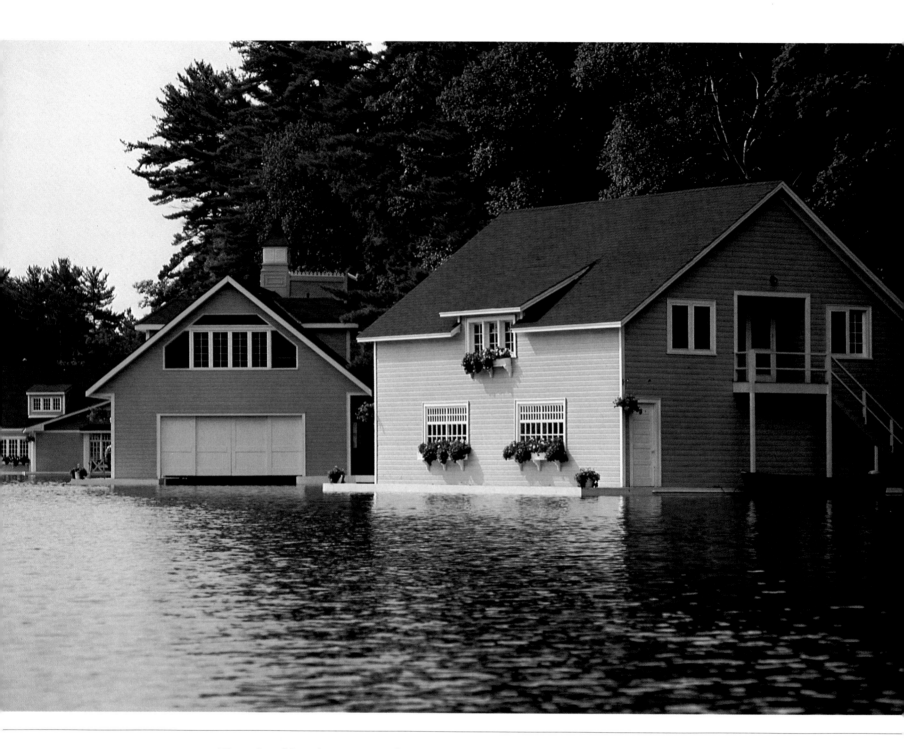

The trio of boathouses. On the left, in
the distance, is the new one. The middle
boathouse has had upstairs living quarters
added to it. The one on the right is the old
original built in 1908, that was spruced
up but not altered.

# KINLOCH

LAKE MUSKOKA

Squirrel Island, the 17 1/2-acre island near Beaumaris on Lake Muskoka, has long been associated with the wealthy group of Pennsylvanians who built cottages here in the early years of the century. One end of Squirrel was purchased in 1910 by W.L. Mellon, founder of Gulf Oil Corporation, and Camp Vagabondia, his vast cottage, is still the summer home of his daughter, Mrs. Thomas Hitchcock of New York. The southeast half of the island was originally owned by Mellon's friend William Donner but has changed hands several times over the years. Named Kinloch by former owners, it is now owned by Peter and Jennifer Gilgan of Oakville, Ontario. Gilgan, father of eight, explains, "We kept the name because it means something like 'gathering of the family at the lake,' and it seemed to suit."

Since purchasing the property in 1988 the couple has thoroughly renovated the large cottage and boathouses. One boathouse was altered to include a second-storey living quarters; another was restored; and a third was newly built with five slips for the family's boat collection, which ranges from a pontoon to the *Dolphin II*, a 31-foot Ditchburn. This stunning trio of boathouses, all decked out in mint-grey siding with white trim, is much admired and photographed. Boaters passing by invariably slow down, intrigued by architectural details and the spectacular window boxes spilling over with flowers.

The boathouses are on Millionaires' Row, the aptly named channel between Squirrel Island and Tondern Island. Once a week during the season, the restored steamboat RMS *Segwun* takes passengers along this route for a look at the palatial cottages, lavish gardens and immense boathouses that line the shore on either side. "If there's one thing that is uniquely Muskoka, it's boathouses like these," says noted Muskoka architect Tony Marsh. "They're much more visible than the cottages, which are often hidden in the trees."

The Gilgans hired Tony Marsh to draw up plans for their new five-slip boathouse and for the restructuring of one that had been built around 1908 by one of Muskoka's master builders, Peter Curtis. "Boathouses are really just garages for boats," adds Tony Marsh. "It's details like trellises, cupolas and window boxes that make them so interesting."

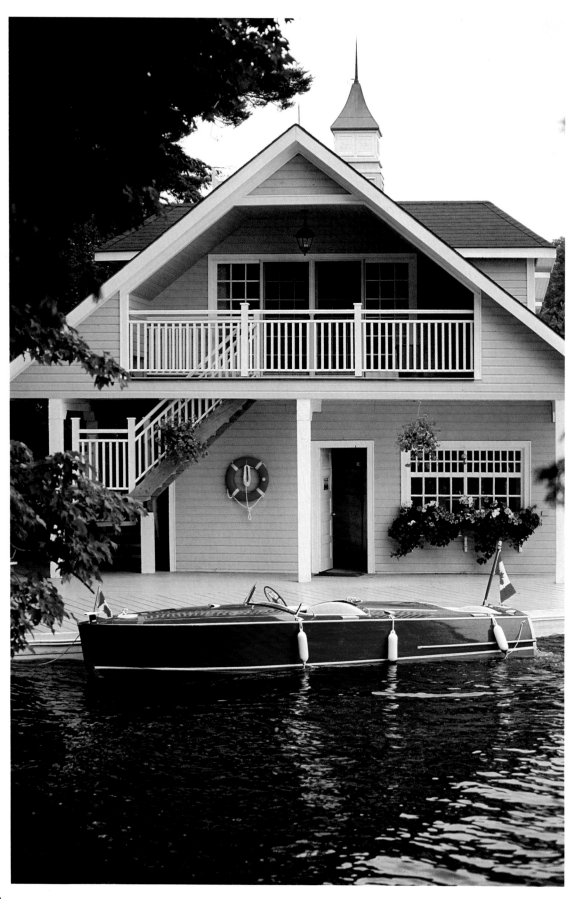

Architect Tony Marsh likes to use traditional Muskoka forms like pitched roofs, gables and cupolas in his boathouse designs. The roof extension here allowed for a covered balcony. Tied at the dock is *Uncle Henry Too*, a 1955 Chris Craft Gentleman's Racer.

The new boathouse was designed with five 22-foot-long slips. Stairs lead to a second level that is currently used as storage space.

Two classic Ditchburns occupy the restored boathouse. *Jesamy*, in the foreground, was built in 1924. Only 19 feet long, she is reportedly the smallest Ditchburn on the lake. *Dolphin II*, with flaps up, is a 31-foot launch built in 1929. Against the wall are two totem poles bought for the island's mini-golf course.

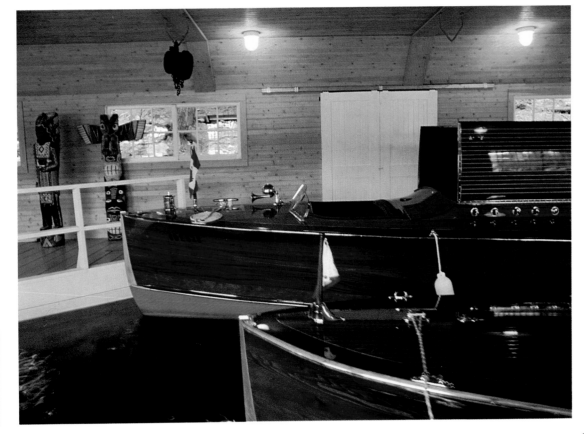

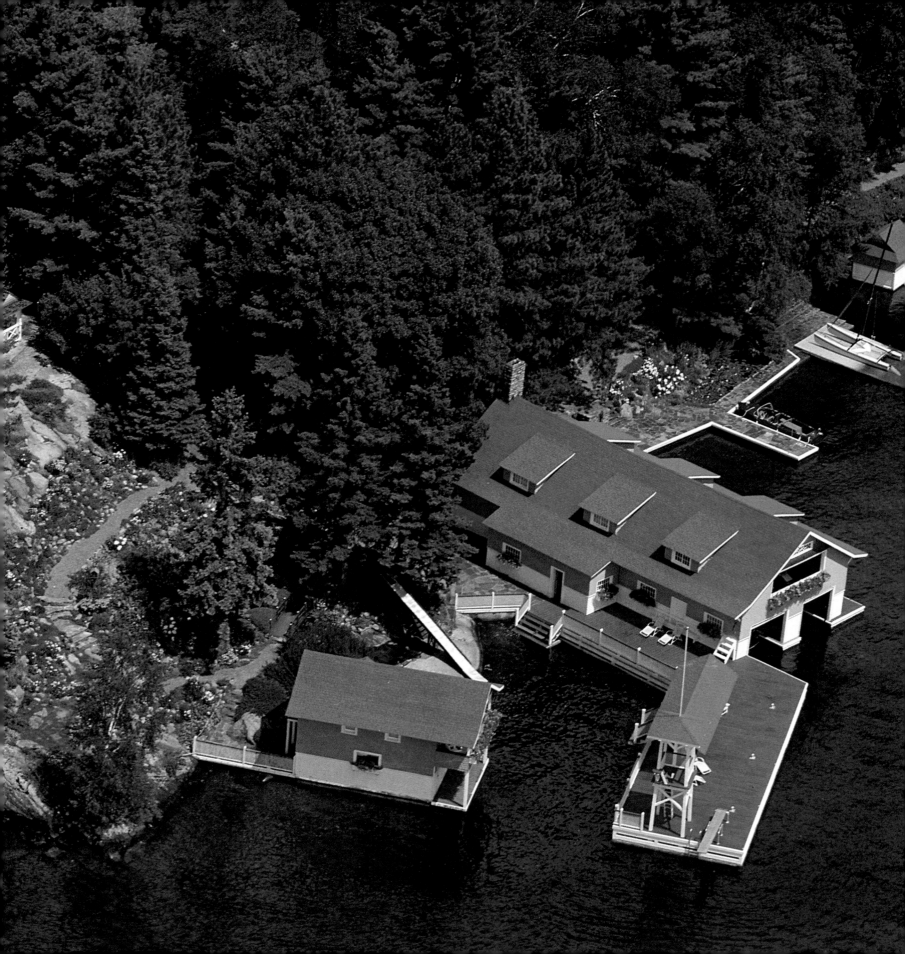

———— 13 ————

# LLANLAR

L A K E   R O S S E A U

On midsummer days, when the gardens are in full bloom and the window boxes at their luxuriant best, there is no more colourful sight in Muskoka than the boathouses of Llanlar. Set in a sheltered bay between two rocky promontories, this property has been in the same family since 1908, when American Joseph Irwin bought it from Reverend Elmore Harris.

There are splendid gardens throughout the property, a legacy of Irwin's granddaugher, Elsie Sweeney, who was once the grande dame and gardener extraordinaire of Llanlar. The gardens were planned and planted during her time here, from 1926

until she died in 1972. And sometimes they were opened to the public to raise funds for the Windermere churches. Today the gardens are maintained exactly as she would have wanted them by Miss Sweeney's nephew, J. Irwin Miller, and his wife, Xenia. The Millers and their five children and ten grandchildren share the property at Llanlar every summer.

The whole place is beautifully cared for and kept freshly painted in sunny yellow with white trim and rusty red docks. A perennial rock garden climbs the hill behind the smaller dry-slip boathouse. The lower level of this boathouse is used to store canoes and sailboards, and

upstairs there is a sitting room that leads to the flower-filled balcony. Built in 1920, the large boathouse has four slips, one of which houses the *Llano*, the Millers' classic 30-foot Ditchburn cabin cruiser. Upstairs there is one huge room, about 50 feet long, with scrubbed maple floors, basswood walls and a stone fireplace. In Miss Sweeney's heyday, this was a well-used party room and decorated in her favourite Italian style, with blue damask sofas and plenty of colourful ceramics. After she died in 1972, Llanlar sat empty until 1976, when it was reopened for the August wedding of Irwin and Xenia Miller's daughter Margaret. The vast woody room above the boathouse was filled with flowers for the occasion, and the structure shook from the enthusiastic dancing of a hundred wedding guests. "My husband was nervous that the floor would fall in," Xenia Miller recalls, "but it survived the wedding. The next year, though, we had to prop up the whole place."

The room has since been redone in more contemporary style and is used by the Miller grandchildren as a rainy-day playroom. Still in place is the original old wicker, the framed British Railway travel posters collected in the 1930s, and Elsie Sweeney's practise piano, which miraculously stays in perfect tune.

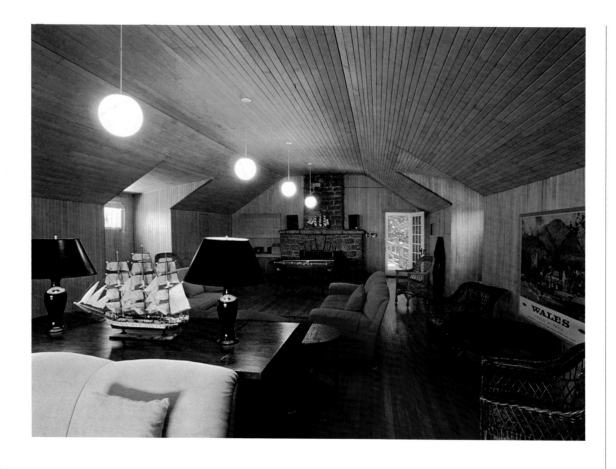

Though now used as a rainy-day playroom by the Millers' ten grandchildren, in its heyday in the late 1920s this immense room was popular for parties. The wicker furniture is all original to the cottage.

Japanese footbridges, waterfalls, fountains and thick carpets of flowers distinguish the property. For more active fun, there is a water slide and a diving tower.

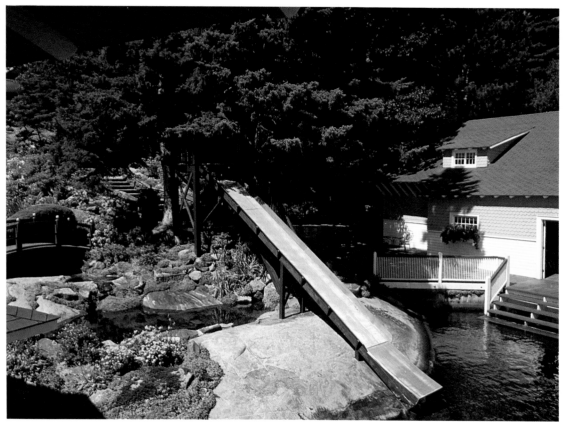

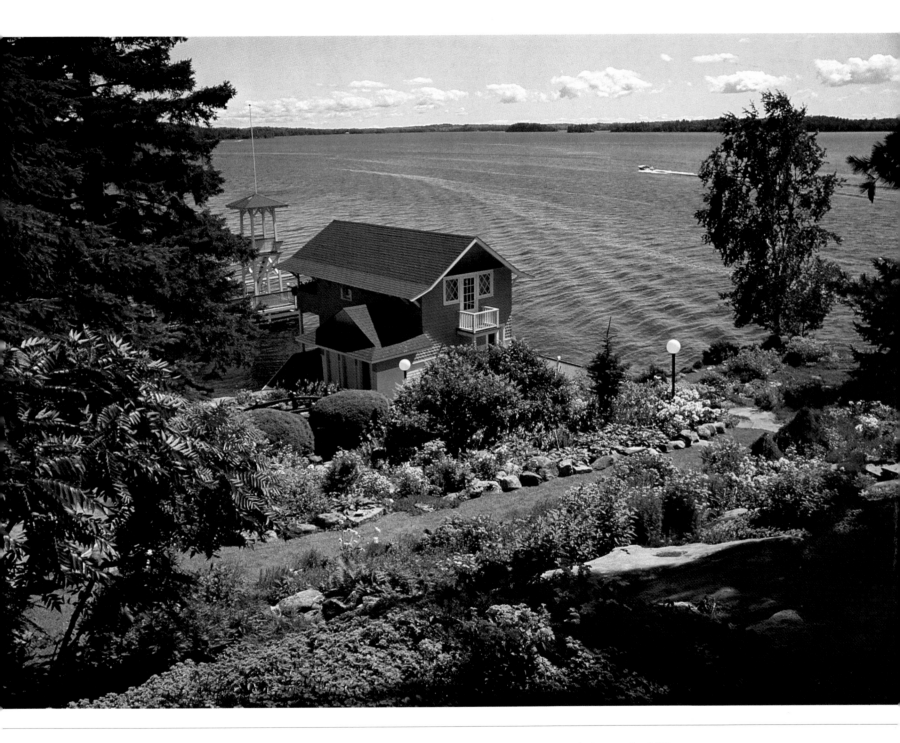

Red gravel paths wend down the hill
through the perennial rock garden to the
docks and boathouses of Llanlar. The
hilltop gazebo provides a lovely view
of Lake Rosseau.

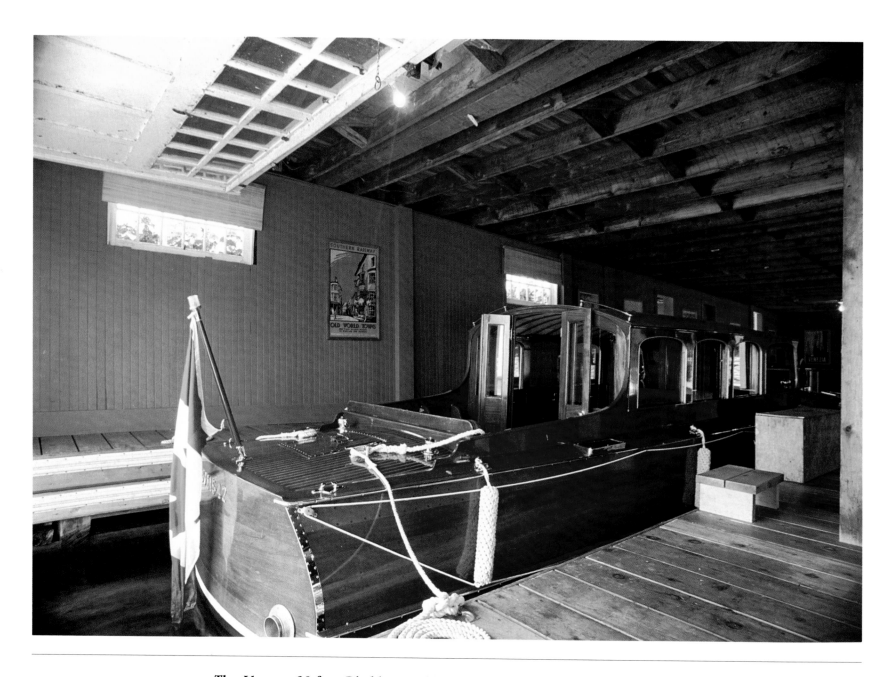

The *Llano*, a 30-foot Ditchburn cabin
cruiser, snug in its berth in the
large boathouse.

From the balcony of the small boathouse one can see Llanrwst, the cottage built in the 1950s by the famous American architect Eero Saarinen. It too is part of the Miller property and offers an unusual contrast to the Victorian-style boathouses.

**Viewed from the cottage deck at dusk, the
log boathouse appears to float on
Lake Muskoka.**

# THE LOG HOUSE

### L A K E   M U S K O K A

George and Barbara Kiddell wanted their new boat-house to blend with their cottage on Lake Muskoka, which had been constructed many years earlier from a 150-year-old log cabin. Since Muskoka boathouses are not traditionally made from 10-inch square-cut timbers, this was not an easy task. However, they were able to find logs north of Huntsville that closely matched the old logs, and construction began in the winter of 1989. Family photo albums proudly document the building's progress: sinking the cribs through the ice in winter; cutting and assembling the logs on land; bringing the logs across the lake by barge in the spring; and then, with two barges and cranes, putting up the entire structure in one day. Barbara Kiddell remarks, ''Modern technology makes log building a lot easier than it used to be.'' Midway through the construction, though, they ran into a problem. A neighbour's objection interrupted their progress and forced them to move the boathouse 10 feet further from a shared lot line. Rather than abandon the project altogether (as the neighbours had hoped), they hoisted the building and moved it the required distance.

Today the boathouse presents a pretty picture from the land and from the lake. Every detail has been carefully considered. The large deck, which can be partially covered by a retractable green-and-white awning, is an ideal playground for the Kiddells' seven grandchildren. Inset in the railing is a latched gate that opens so the children can jump off the deck into the water. The upper-level living quarters, 500 well-planned square feet, includes two bedrooms, a kitchenette and a tiny bathroom. The rooms are decorated in log-cabin style with white country curtains and Canadiana pine furniture. Other authentic touches include wide floorboards from an old house and weathered ceiling beams that Barbara Kiddell rescued from a nearby barn.

To the Kiddells' delight, the logs are weathering quickly and in just a few years have almost matched the silver tones of the original old cottage. From their master bedroom in the boathouse, the Kiddells enjoy a sunrise view with Pine Island across the way and Lake Muskoka in all directions. According to Barbara, ''It's a perfect place to wake up on a summer morning.''

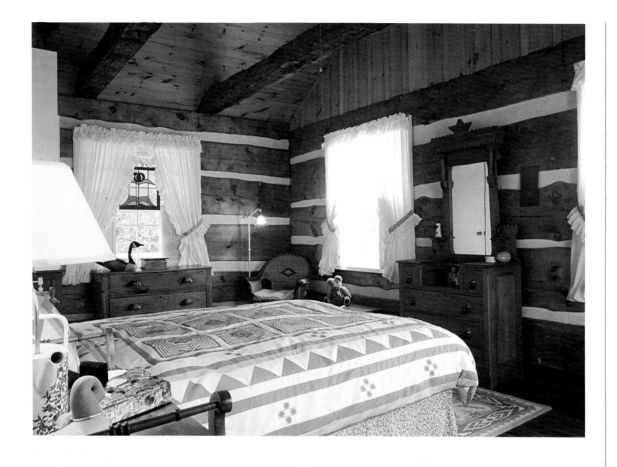

In keeping with its log-cabin style, the interior is filled with quilts, ruffled curtains and Canadiana pine antiques.

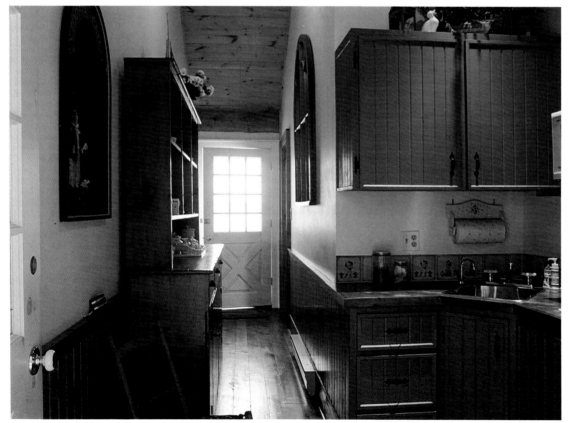

The compact kitchen is at the end of a long hallway and contains a bar fridge behind the blue cabinet door, a small corner sink and a micro-convection oven. "Everything we need to cook our own breakfast is down here," says Barbara Kiddell. The antique Welsh dresser on the left houses a collection of blue-and-yellow Italian pottery.

Approaching the boathouse at dusk. A wooden walkway links the deck to the shore.

# WINGBERRY COTTAGE

## LAKE MUSKOKA

When Harry and Lynda Littler bought Wingberry Cottage on Lake Muskoka eighteen years ago, the property consisted of a rambling 1920s cottage and a one-slip boathouse. But that was before Harry started collecting boats. Now spreading across the shoreline are three forest-green boathouses, the newest of which is an immense home designed specially to shelter six gleaming antique mahogany boats. People call it "Harry's Museum," and it is a monument to Muskoka's boatbuilders. Displayed inside with the boats is an assortment of boating paraphernalia: framed Ditchburn drawings are mounted on one wall beside boat-show posters and sepia photographs of vintage craft; restored wicker chairs from old cabin cruisers surround tables stacked with boating magazines; and just inside the door is a hand-engraved wooden sign listing the names and vital statistics of every boat in the Littler collection.

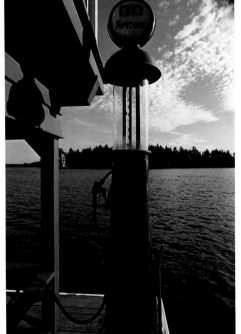

Four 60-foot slips house the boats, all built between 1919 and 1938. In slip one, there's *Wingberry*, a 32-foot Ditchburn; in slip two, *Nika*, a 36-foot Minett; in slip three, a Duke Playmate and a 1935 Greavette; and slip four houses a 1919 Gentleman Racer and a 22-foot W.J. Johnson launch. A seventh, newly acquired treasure is *The Barnes*, stored in a separate boathouse. In all, a dazzling display of soft leather, highly polished wood and spotless chrome.

The 2,400-square-foot interior is immaculate. The walls are panelled in tongue-and-groove pine; the windows have dark green venetian blinds to keep out the sun and heat; and fans whir slowly overhead. Beside each boat lies a custom-made mat with the boat's name embroidered on it. These prize craft lie almost motionless, tightly tethered with thick white ropes.

Down the shore from Harry's Museum is another boathouse, with a two-slip boat port, a sauna, change room, tool room and a built-in bar at water level. Upstairs is a self-contained guest cottage. Living space in a third boathouse is used by one of the Littler children. With its array of green-and-white cottages and boathouses spread along the shore, and the perpetual coming and going of boats, it is not surprising that, as Lynda Littler says, "People sometimes mistake our place for a summer resort."

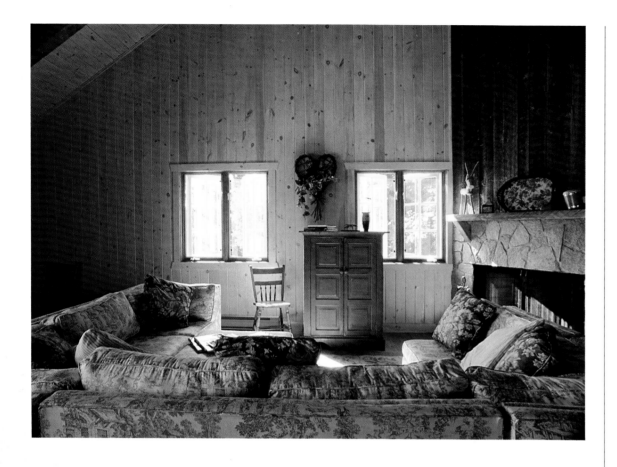

Lynda and Harry Littler both worked on the design of their guest-cottage boathouse. They chose barnwood, antique pine and a pink stone fireplace to create a cozy atmosphere for their numerous weekend guests.

The back wall of Harry's Museum, a boathouse specially designed to house antique boats and a shipshape display of boating memorabilia.

OVERLEAF:
The 1927 gas pump is still used to fuel the family's fleet of boats.

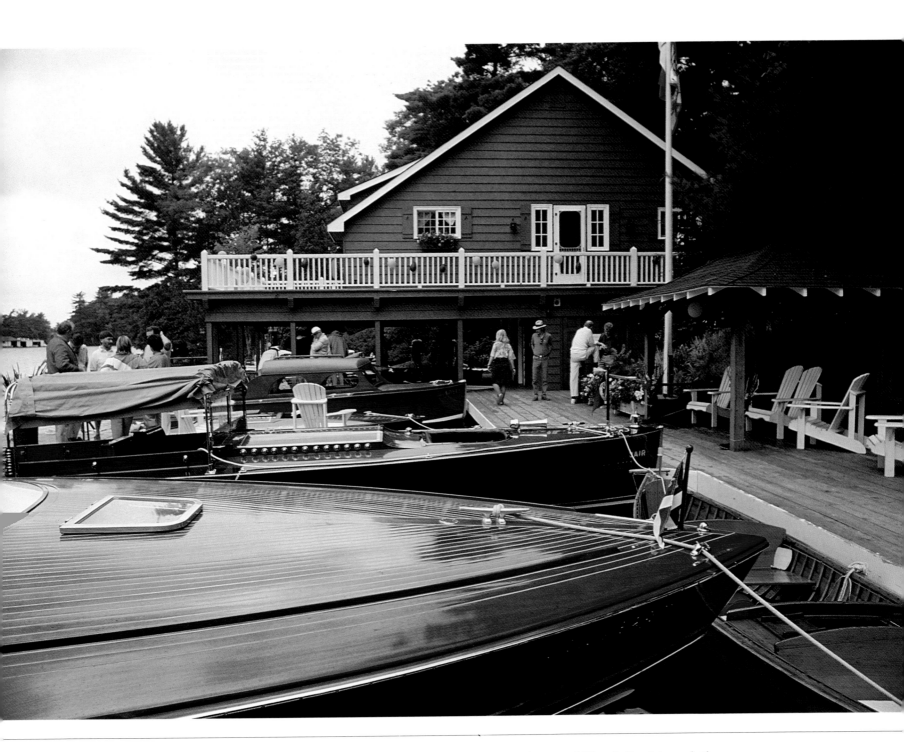

The 1992 Antique and Classic Boat Association Summer Rendezvous was held on a cloudy August afternoon at Wingberry Cottage.

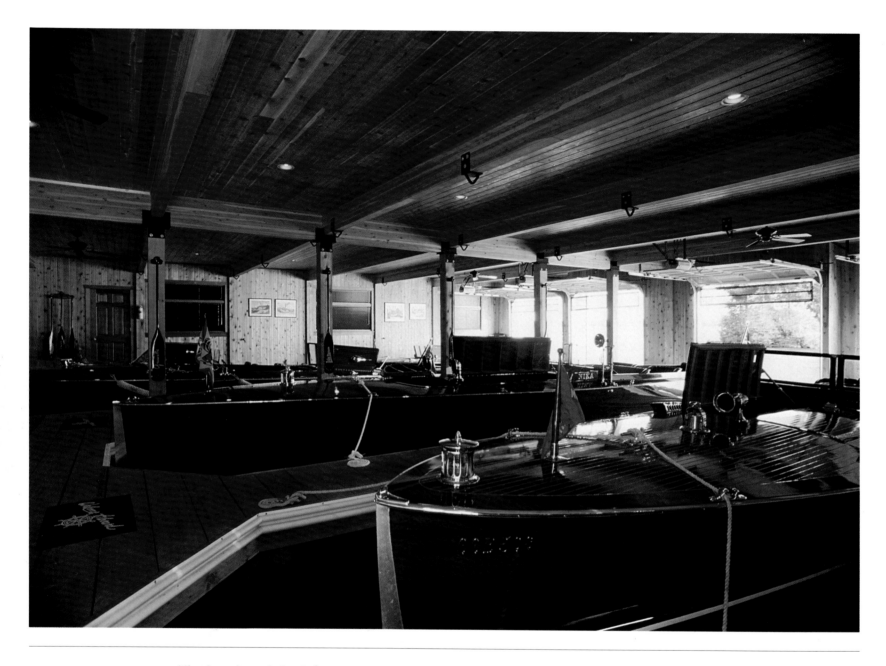

The interior of the 2,400-square-foot four-
slip boathouse that shelters the Littler
collection of vintage Muskoka boats.

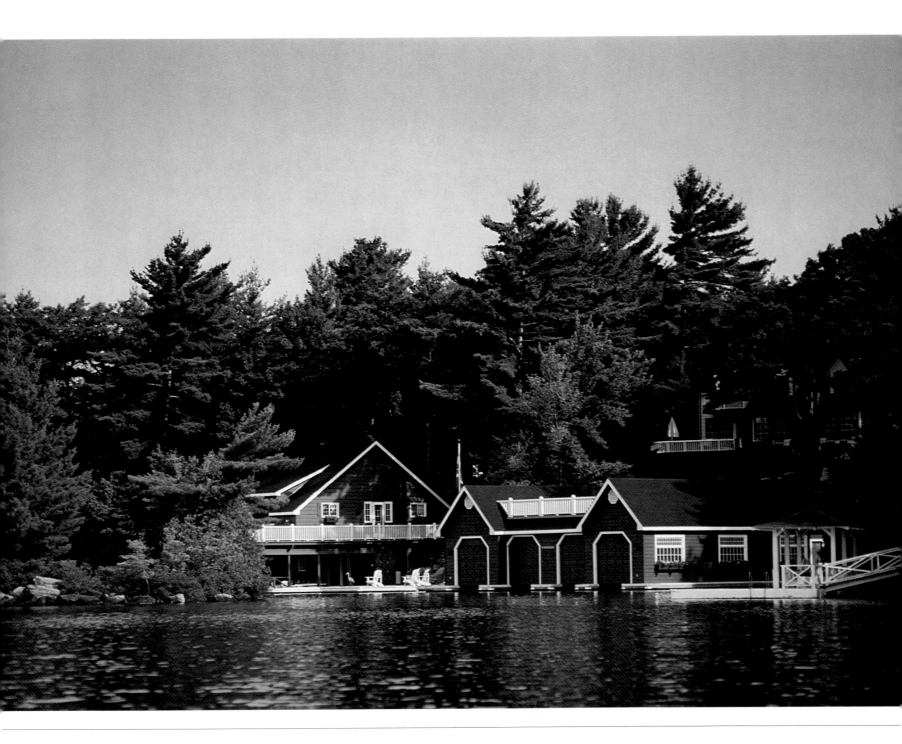

Two of the trio of Littler boathouses on Lake Muskoka. On the right is ''Harry's Museum,'' which houses the family's antique boat collection. The boathouse on the left is the guest cottage.

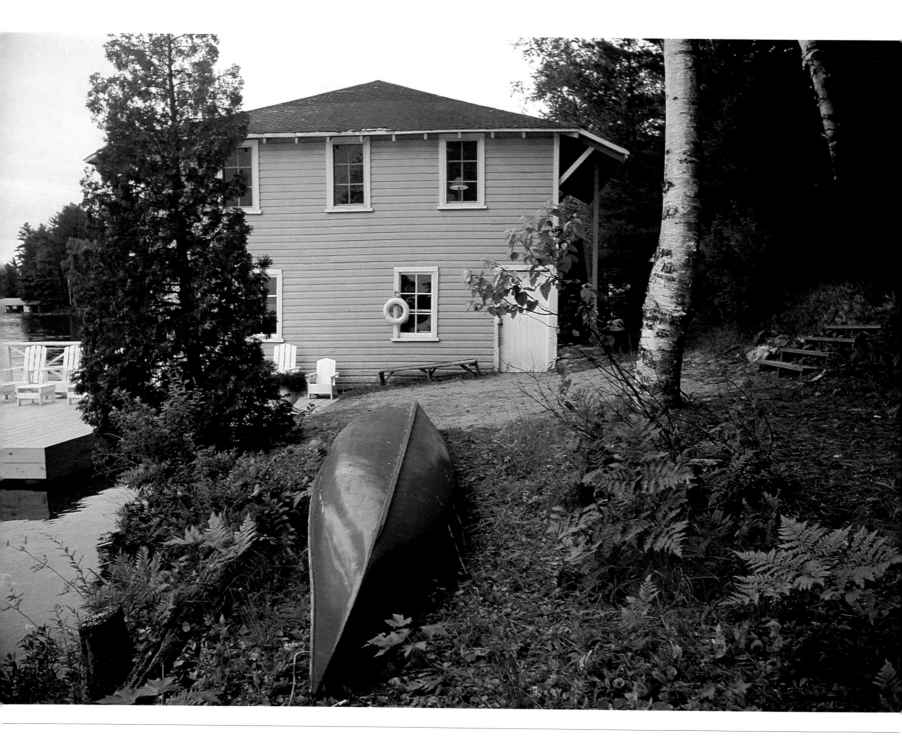

The boathouse at Langton House on Lake of
Bays is almost a hundred years old and
once had a large dock area where
steamboats would land.

# LANGTON HOUSE

LAKE OF BAYS

There is a certain magic connected to a cottage that has had a former life as a summer lodge. The happy memories almost seem to be held within its walls. When Viki Mansell and Kevin Keeley bought Langton House on Lake of Bays in 1985, it had long ceased to be a hotel but was still in remarkably good condition. There wasn't one piece of rotted wood, even though the main house and boathouse were both built in 1895. It had been a farm property first, then the farmhouse was turned into a summer lodge. This was a common transformation in the early years of the century, when farm families saw the opportunity to earn extra income from the growing tourist trade.

Langton House sat on a grassy slope that dipped down to a curve of sandy beach on Lake of Bays, an ideal setting for vacationing families. In its heyday, in the twenties and thirties, Langton House had a separate dance hall that drew crowds from around the lake. The boathouse was used as a dormitory for the musicians. Some of their names and the instruments they played are still scribbled in pencil on the wooden bedroom wall.

But Viki and Kevin and their two young children use Langton House as a summer cottage. There is plenty of room for weekend guests and extended family—and plenty of work to keep everyone occupied. Their first task was to return the buildings to their simple rustic charm.

The boathouse, where steamboats full of hotel guests once landed, had been neglected. The cribs needed shoring up and a new dock had to be built along one side. Inside the boathouse, the old cedar tongue-and-groove walls were in good shape, and the pocket windows, which slide up and down, only required new screens to let in the fresh lake air. The pine floors were scraped, to rid them of a brown oily varnish, and left bare. "Viki and I like things untouched," says Kevin, "so we try to bring a place back to its origins." In late afternoon the boathouse takes on an amber glow. Sun slants into the main bedroom through the windows that face west down the lake towards Baysville. "The light in this boathouse is magical," enthuses Viki. "It's wavy and sparkling, and you do have the sensation of being on an unmoving boat."

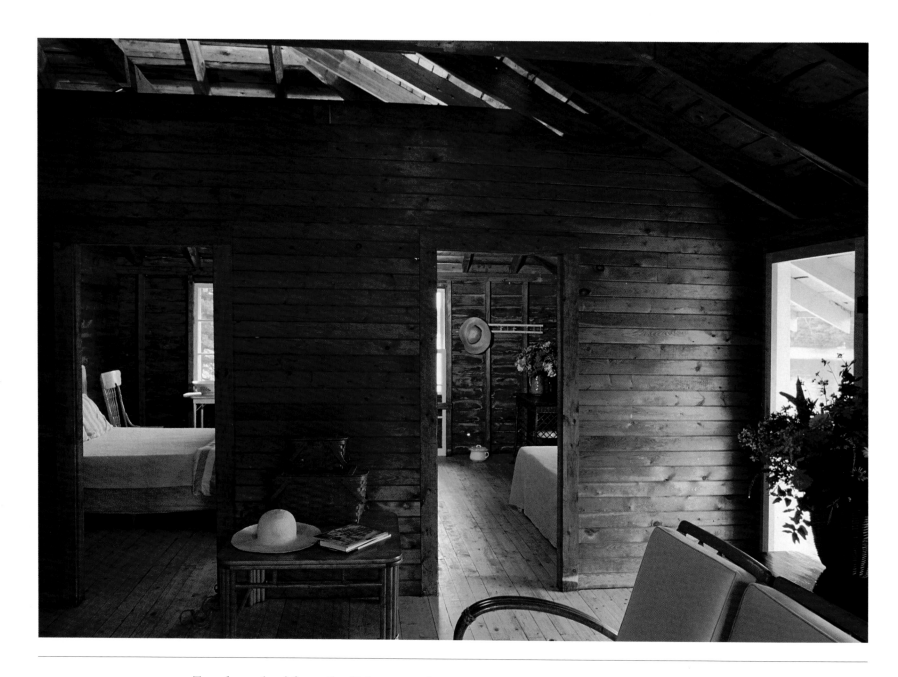

Two doors lead from the living room into the master bedroom, which was originally two rooms. All the pine floors were scraped clean of varnish, but no planks needed to be replaced. The walls are all double-sided tongue-and-groove cedar and don't reach the ceiling. ''There's not a lot of privacy in these bedrooms,'' comments owner Kevin Keeley.

Viki Mansell loves this blue-and-white fabric for its fresh, summery look against the weathered cedar walls.

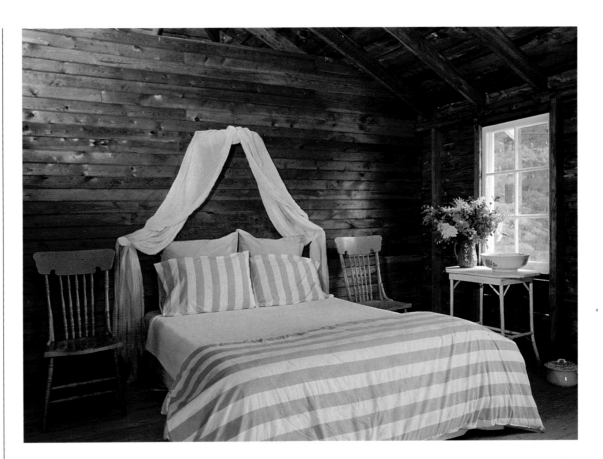

The rustic bathroom has a sink with running water but no toilet. The fresh flowers in every room come from Viki's large cutting garden behind the cottage.

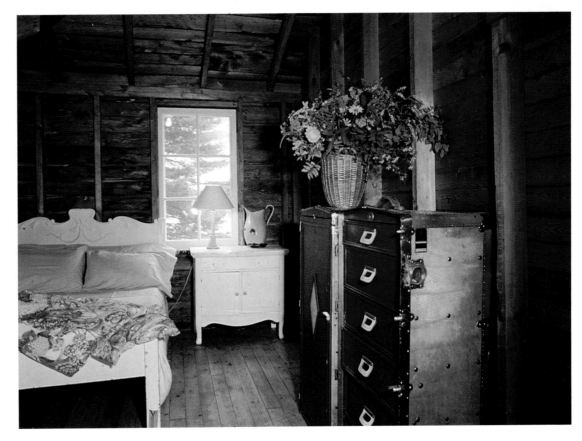

The slap-slap of water and the sweet scent of cedar make this boathouse bedroom a wonderful place to sleep. There were no cupboards in any of the rooms, so antique armoires and travelling trunks like this one are used for storage.

99

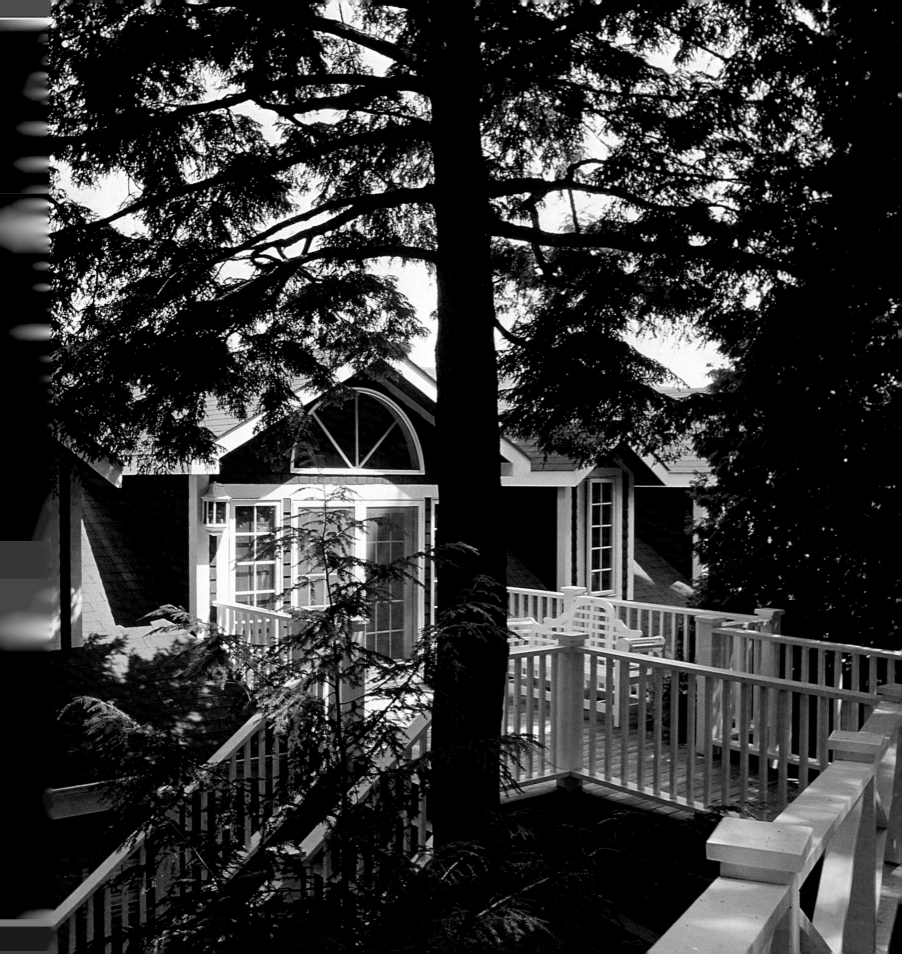

# SUNSET ISLAND

L A K E   J O S E P H

Sprawled along the shoreline of Sunset Island on Lake Joseph is an immense boathouse, possibly the last of its size to be built in Muskoka. Just like the original shingle-and-stone cottage built in the early 1900s, the new boathouse has Old Muskoka style. Manicured gardens and immaculately raked walkways encircle the island, which also has two smaller boathouses and a sleeping cabin, all stained deep chocolate-brown with bright white trim.

The permit to build the boathouse was granted in 1985, before new by-laws controlled the amount of allowable living space in boathouses. Because of deep water and engineering complications, it took five years to build. With four slips, 3,300 square feet of living space and fourteen underwater cribs for support, the boathouse rivals extravagant structures built at the turn of the century.

Elizabeth deJong, an interior designer, took over after the construction and transformed the second storey into a comfortable retreat. Despite the boathouse's size, its interior seems cozy, full of homey pine and overstuffed chairs. Two dormered rooms occupy opposite ends of the boathouse, joined by a long, narrow corridor. At one end is the master bedroom with a sitting area and French doors leading to a private covered balcony. At the other end is a gathering room with two conversation groupings, a compact wet-bar and built-in hutch, and another balcony. In the master bathroom, a jacuzzi bathtub is tucked into the window dormer, and there is still room for a generous glassed-in shower and a double-sink vanity along one wall. With allusion to the family's other full-time residence, in Switzerland, the pine valance in the bathroom has a Swiss design of cutout hearts.

To take full advantage of the interesting dormers in the two main rooms, Elizabeth deJong designed window benches with drawer space built in below. Port Carling cabinetmaker Rob McKee custom-built all the pine cabinets and trim details. Summery prints in pink, green and blue blend with the mellowing pine and the background of trees and blue water seen through every window.

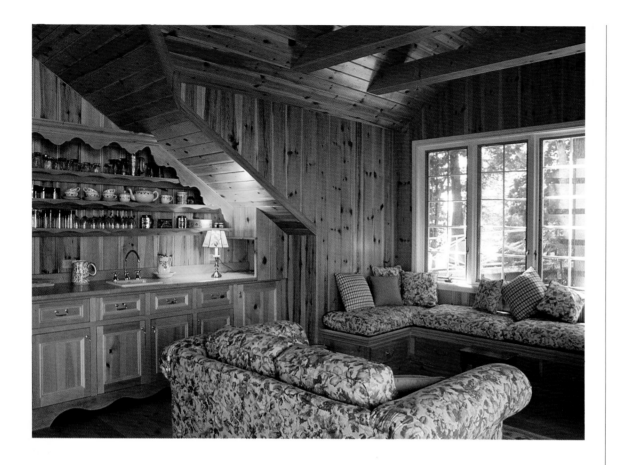

There is no real kitchen in this boathouse, just this built-in hutch with a bar sink, a microwave and small refrigerator inside the cabinet. The cushioned window seats have storage drawers beneath them. They are lovely places to curl up and read on a summer afternoon.

Angular roof lines created by the gables add to this interesting master bedroom. Fabrics were chosen to blend with the outdoors, and windows on three sides allow cross breezes to drift through the room.

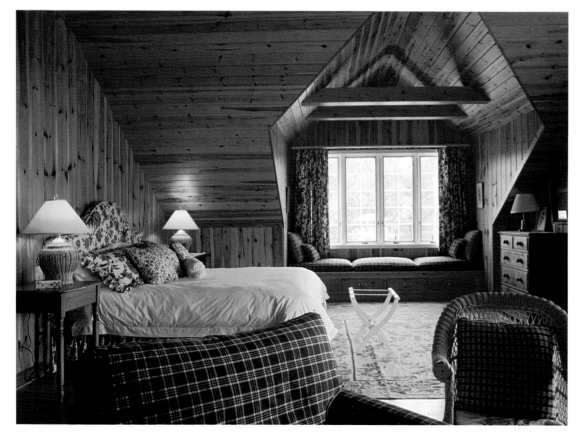

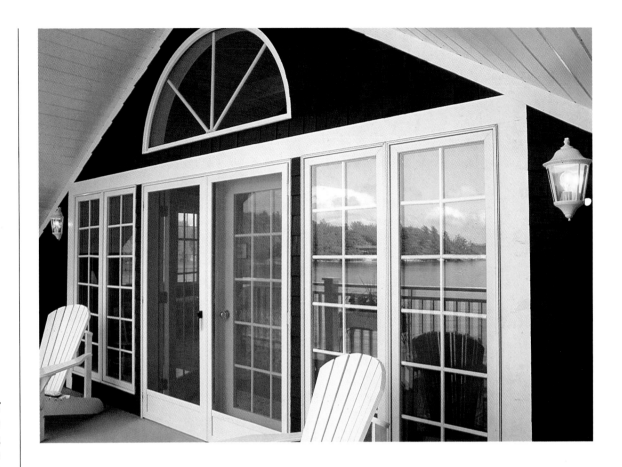

The two gables have deep roof projections that cover an outside deck. To keep the rooms from being darkened by this feature, the designer filled the triangle with glass, using three sets of French windows and doors, and a fanlight in the peak of the gable.

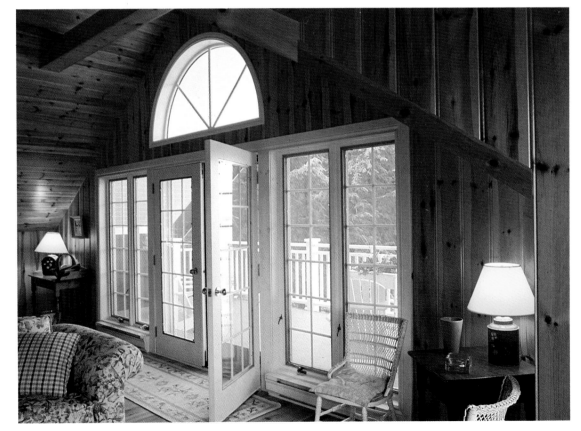

**A perfect summer day on Lake Joseph as
viewed from the boathouse deck.**

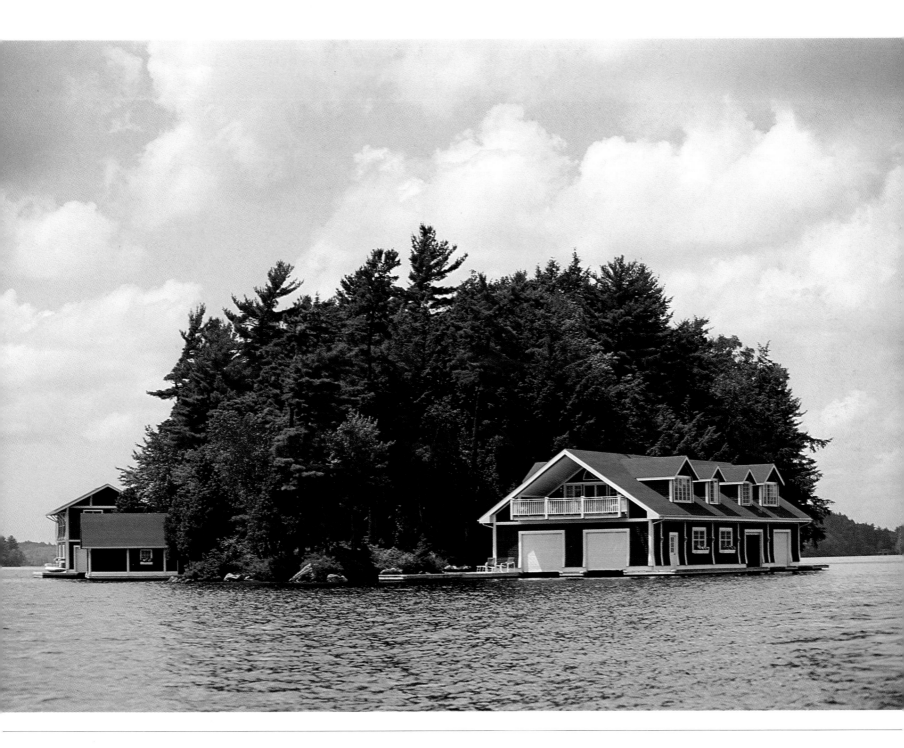

The new boathouse (right) was designed to complement the island's two other boathouses (left).

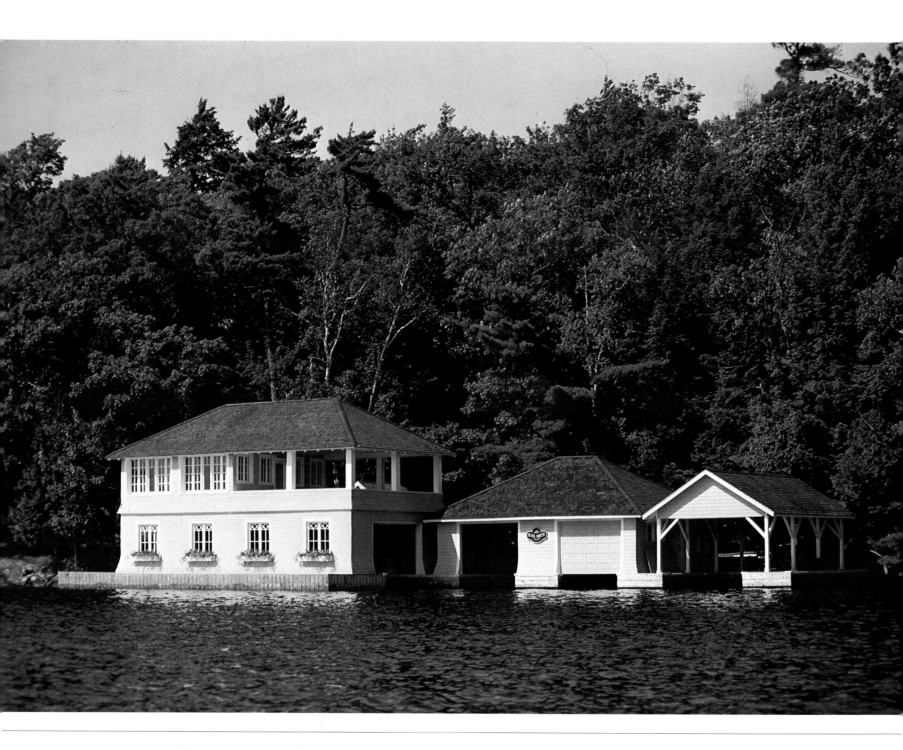

**The newly restored boathouse on Black Forest
Island was built in the 1890s.**

# BLACK FOREST ISLAND

LAKE JOSEPH

Black Forest Island, with its fine old buildings, is regarded as one of Muskoka's heritage treasures. Many of the neighbours have fond memories of the place and were pleased when its new owners undertook the restoration of the island property. The lumber baron who built the cottage and boathouse in the 1890s used the finest of materials and employed the most talented craftsmen of the day. By 1909 the property had been sold to Clarence Black, an American who named the island Black Forest, alluding to his name and to his favourite region in Germany. It was in his time that the boathouse acquired its fairy-tale reputation. Black used to hide lollipops around the boathouse for the children, and so it became known as Uncle Lollipop's boathouse. The room upstairs also intrigued the children. It was a barbershop where Black kept a barber's chair, in which he was given his daily shave by one of the male servants.

By 1990 the two-storey shingled cottage and the boathouse, had fallen into disrepair. The boathouse had suffered rain damage, and the living quarters had long since become unlivable and been relegated to storage space. "We decided to fully restore the property to the way it had been originally," explains the new owner. "It was a massive undertaking, but now I think it was well worth it."

The boathouse was lifted so that all the cribs and docks could be replaced. New windows were handmade to match the diamond-shaped originals on the lower level and the multipaned ones in the living quarters. A new V-joint ceiling was installed and a new pine floor. Duradeck was put on the floor of the large covered porch, and pot lights were installed in the new ceiling.

The owner felt lucky to have "a lot of very fussy people working on this project. Every detail had to be perfect." Now the big, old cottage is in pristine condition, and there is a tiny treehouse for the grandchildren, a guest cabin, and a sauna on the property, all miniature versions of the cottage. The upstairs of the boathouse, once Uncle Lollipop's barbershop, is now a sun-filled party room complete with a reproduction Wurlitzer jukebox. "It's like a dream room for me," says the owner. "I love every corner of it."

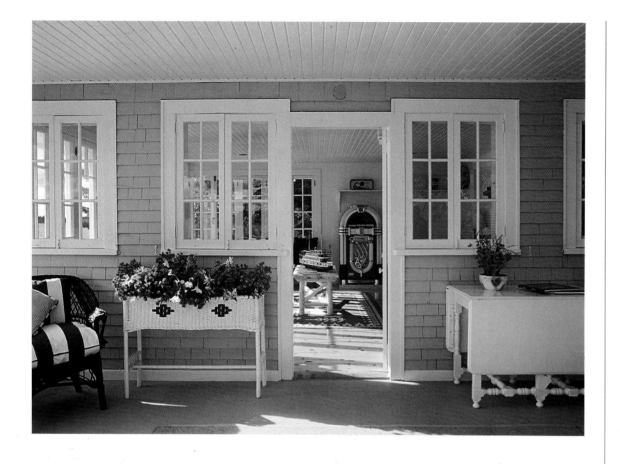

The covered porch doubles the living space of the boathouse's upper level. At night, tiny pot lights in the ceiling make it a romantic spot for dancing. Viewed from the porch is the new party room with its reproduction Wurlitzer jukebox. Special bracing was installed under the jukebox to keep the floor from shaking while the music is playing. Green-and-white canvas cushions cover the handcrafted pine furniture made by Parry Sound carpenter Wayne Brownlee.

A panoramic view of Lake Joseph from the boathouse. Gallons of forest-green paint were used in the restoration of Black Forest Island, some of it on this antique wicker porch set.

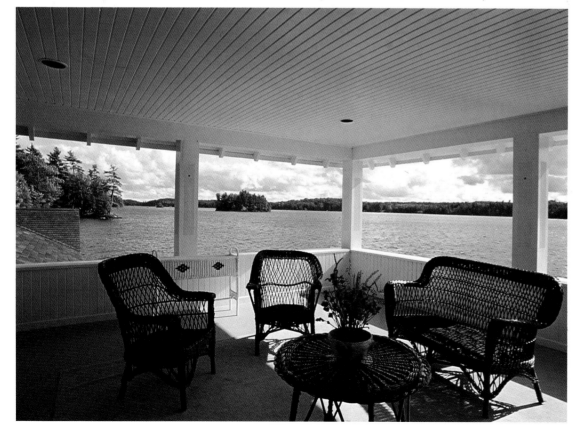

OVERLEAF:
The scale model of the *Sagamo*, one of the last of the fleet of Muskoka steamships, was made by Captain John Dionne, a retired Great Lakes seaman.

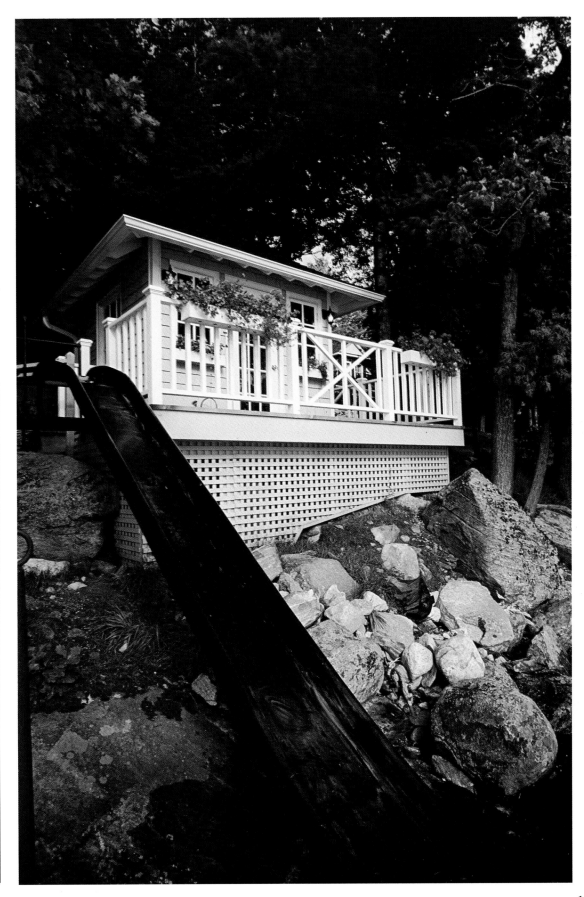

Along the shore from the boathouse is a sauna that was designed by contractor Jamie Blair as a miniature replica of the cottage. Both a water slide and a set of wooden stairs lead into the lake. The cedar-lined interior has a shower and washroom, as well.

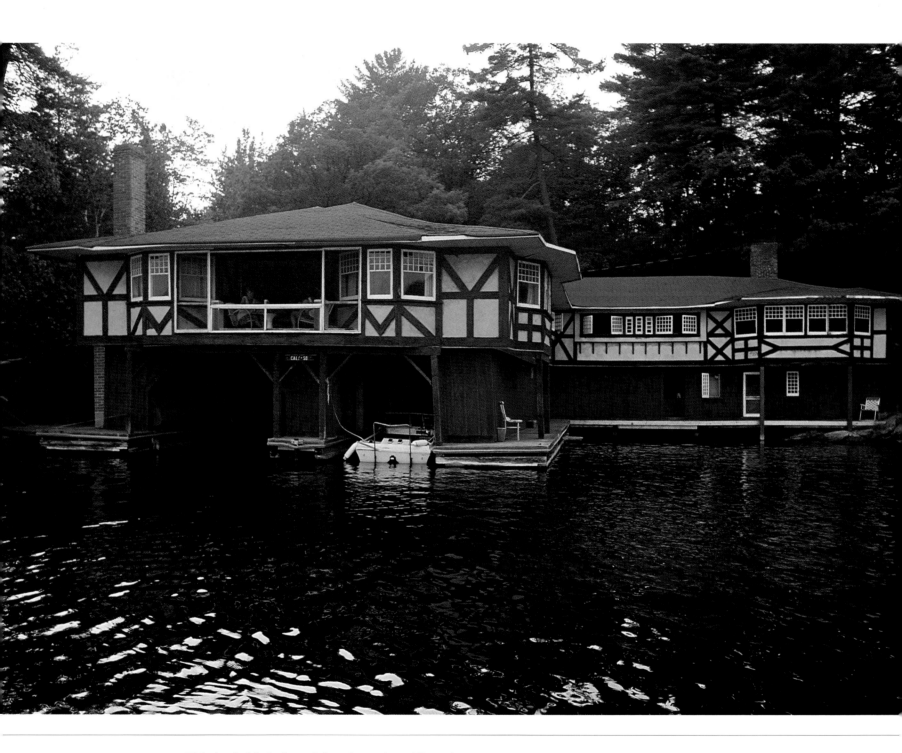

With its half-timbered facade and mullioned
windows, Calypso looks more like an English
manor house than a Muskoka boathouse.
''We're always shoring it up and it's still
lopsided,'' complains Tannis Malabar.

# CALYPSO

LAKE JOSEPH

One doesn't expect to see a half-timbered Tudor house anchored to the shore of a Muskoka lake, but this is not a usual sort of place. From a distance it looks as though it might even be slipping into the lake. It dips and slants and creaks the way an English manor house might, and inside, the dark panelled rooms smell of cedar and wood smoke. This unusual boathouse is called Calypso, because it is on Calypso Point on Lake Joseph.

"It looks very British because it was built in 1917 by someone who was homesick for England," explains Tannis Malabar, whose uncle Tom L. Hay bought the property from the original owners in 1929. There had been a large cottage, too, but it burned down in 1919 and was never rebuilt. Since then the sprawling boathouse has served as the property's cottage. At water level there are two boat slips full of nesting swallows, and next to them, a small bedroom — "The one we all fight over," says Tannis. Upstairs there is a panelled dining room with a stone fireplace, an old-fashioned kitchen and pantry, a living room with another fireplace, a small screened porch that juts out over the water, and six more bedrooms.

A guest cabin that now sits near the old cottage foundation adds to the bed count. Often, on long summer weekends, as many as twenty-four people stay on the Calypso property. The attitude here is "the more the merrier," particularly on Saturday night, when most everyone gets into costume. The name Malabar is almost synonymous with costumes in Toronto because the family operated a costume-rental store there for decades. Now many of these outfits, from flapper gowns to clown suits, are crammed across coat racks at the far end of the boat slips.

Every summer the Calypso boathouse is shared among three families, the Malabars, the Breaks, and the Farquharsons, all of them involved in the ongoing task of upkeep. Calypso is a labour of love for all concerned. And everyone agrees that it's the best place in Muskoka on a Saturday night!

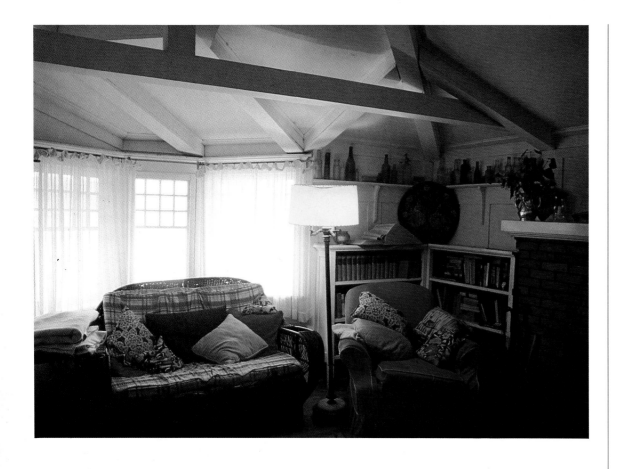

The living room is 40 feet long and 20 feet wide, large enough for two sitting areas including this one full of comfy old furniture.

The long, dark corridors in the Calypso boathouse are reminiscent of an old country inn. At the end of the hallway is a dining room where guests gather at the large oak table before a roaring fire.

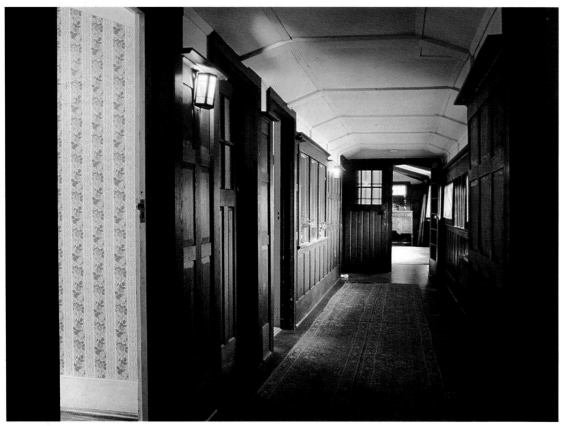

OPPOSITE:
Gourmet meals are produced in this kitchen every summer. Cupboard doors were removed in the kitchen to open up the space and brighten the dark hallway. To the right of the kitchen is a pantry connected to the dining room.

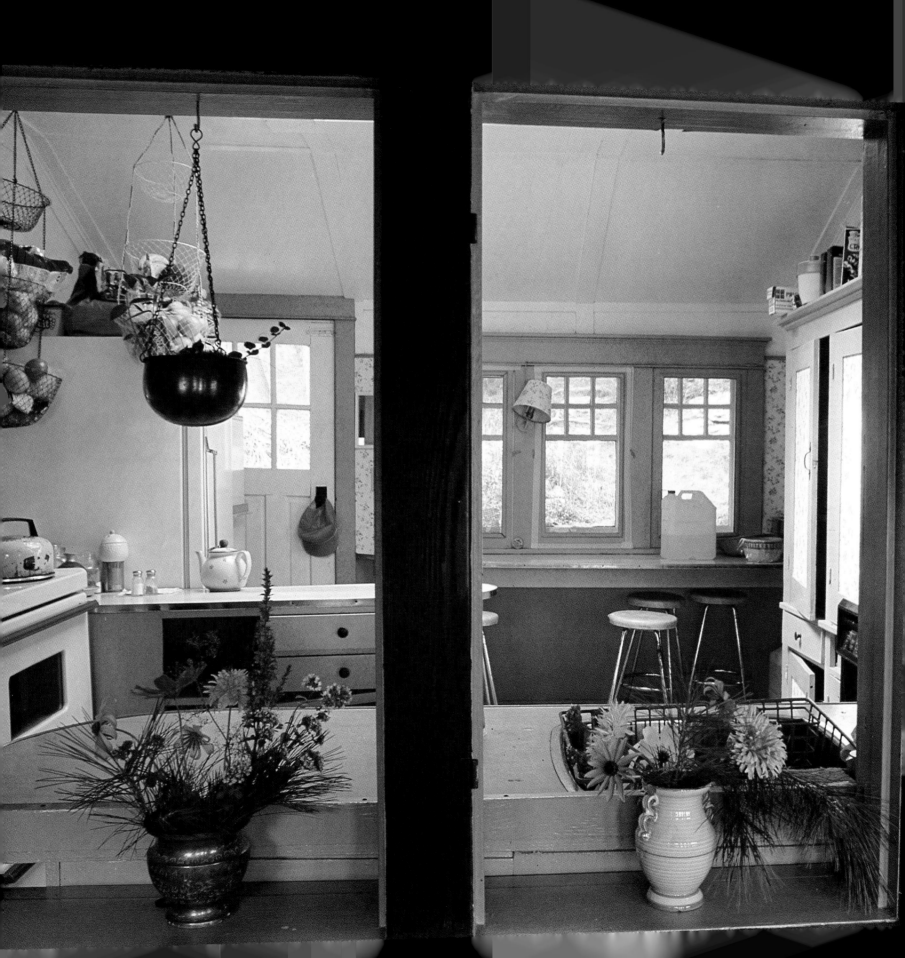

In the long wood-panelled corridor, a stag's
head serves as a hatrack.

Mementos of another era: in the living
room, a well-used piano, stacks of board
games and jigsaw puzzles, and a vintage
wicker plant stand.

The costume department is down where the boats are stored, with dozens of outfits to choose from. Boxes of costume jewellery and other accessories lie scattered on top of the polar bear rug.

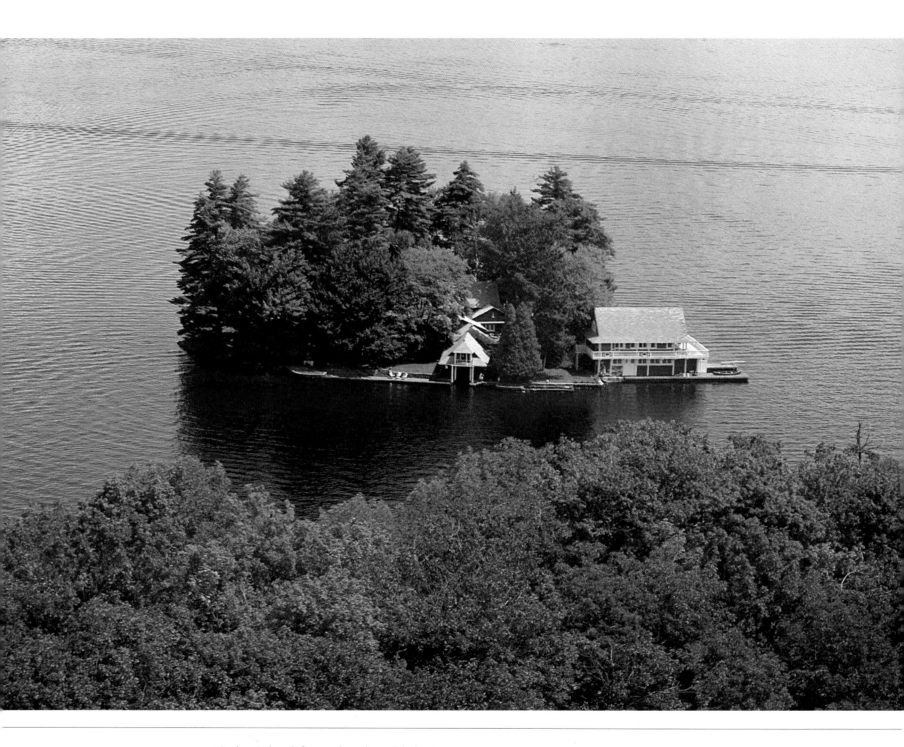

Cedar Island from the air, with its two
unique boathouses. The smaller one was
originally the laundry and the servants'
quarters. The slip beside it was for a
"dippy" (disappearing-propellor boat).

# CEDAR ISLAND

L A K E   R O S S E A U

Few boaters can resist slowing down as they pass this picturesque boathouse on Lake Rosseau. Its architectural features are so appealing that an exact copy was built by a Toronto designer at his cottage property on Lake Simcoe and photographed for the cover of a home-decorating magazine. Many of its features have been copied on other recently built boathouses around the Muskoka Lakes. This Cedar Island boathouse probably dates back to 1895, when Mrs. Lillian Massey owned the island and maintained a large farm on the mainland, now the site of the Muskoka Lakes Golf and Country Club.

Apparently this boathouse was built for one of her smaller boats, since she kept her steamship, the 75-foot *Minga*, in the mainland boathouse that is now the clubhouse ballroom.

Tiny Cedar Island is edged with lush cedar trees and a stone wall. It has a quaint dry-slip boathouse and a rambling cottage built in 1885. The Pollock family of Cambridge, Ontario, have owned the property since 1918, and baby Taylor is the fifth generation of Pollocks to summer here. John Pollock proudly claims to have spent part of every summer of his fifty-six years at the island.

The one-slip boathouse, painted slate grey with white trim, presents a pleasing symmetrical picture, with exposed outriggers, wide eaves and a wraparound balcony. Upstairs are two bedrooms, a sitting room with fireplace, and a kitchen. The living space was originally intended for staff but is now used by members of the extended family. All the interior walls, ceilings and floors are clad in the original fir planks, and a large brick fireplace still dominates the living room, though it no longer functions. "With four fireplaces in the main cottage, we decided we could do without this one," says John Pollock, "especially since things were starting to sag beneath the weight of it. We ended up having the chimney taken off."

The old boathouse requires constant upkeep. The docks and cribs have been replaced twice and there have been several new roofs. Keeping their boathouse looking attractive is important to the Pollocks. This special care is appreciated by the Lake Rosseau boaters who pause to admire the old boathouse each time they pass by.

John Pollock was just a boy when he build this model sailboat with his father. Now John's grandchild occupies the portable crib at left.

On the bedroom wall in the background is a collection of old black-and-white sailing photographs that belonged to John Pollock's grandfather when he was Secretary of the New York Sailing Club. The boathouse interior has barely changed since his time.

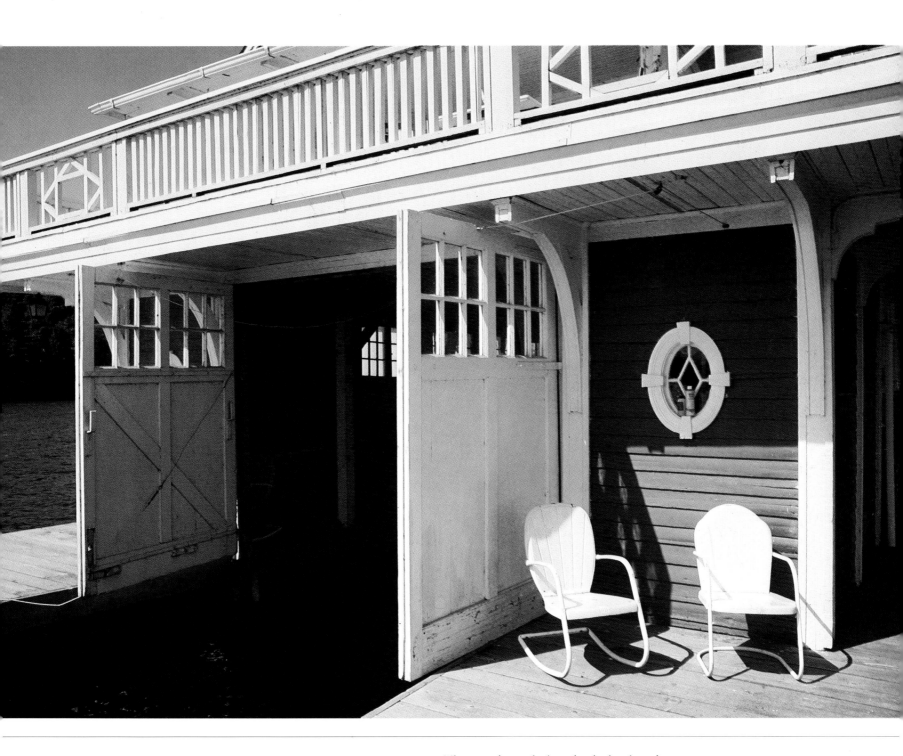

The much copied and admired main boathouse at Cedar Island was built around 1895. The architectural details have been copied on many newer boathouses around the Muskoka Lakes.

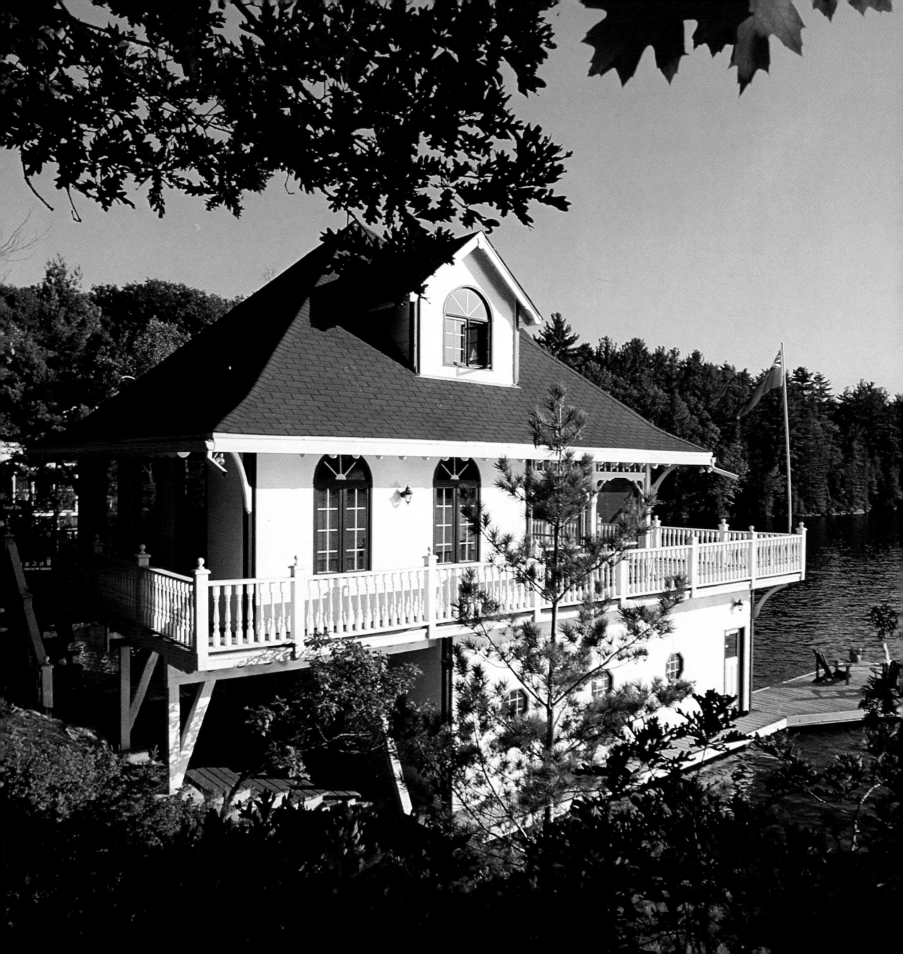

# CHARING CROSS

### L A K E   M U S K O K A

When Leslie Willis was a child, her father used to arrive at the cottage by train on summer weekends, pulling into the Bala station on Friday night. He was a travelling salesman, and the family had a cottage on the Moon River. Leslie can still remember the excitement of hearing that train arrive, so it is not surprising that she and husband Ron, a train buff, bought cottage property next to the railway bridge at Bala. Several trains cross the bridge every day, including the *Canadian* on its way across Canada. The Willises both love to listen to it rumble by.

The construction of their Lake Muskoka boathouse, with its bell-curved roof, porthole windows and interesting gingerbread trim, was a two-year labour of love. They wanted the boathouse to match the cottage that had been built a few years earlier and yet to look a little like a vintage train station, the kind with wide, overhanging eaves and sharply peaked gables. And just for fun, they named their place Charing Cross, after the old London train station.

Collaborating with two Bala builders, Kevin Dick and Dan Goforth of Design and Renovation Co., the Willises almost invented the boathouse as they went along.

Neither they nor the builders had ever built a boathouse before. The building was designed to cantilever out from the shore, with part of the structure anchored to the land. Also unusual is the third storey, which was not part of the original plan. When the Willises saw how much space there was beneath the steeply pitched roof, they decided to add a loft and dormer windows. A spacious screen porch, large enough for a hot tub, was one design requirement. They also wanted the living room to be bright and to offer a view of the lake despite the overhanging roof on the adjoining screen porch. This was solved by installing floor-to-ceiling windows at two ends of the living room and a skylight in the roof. There was a firm construction deadline. The Willises had promised the boathouse to friends for their wedding in August 1991. It was finished just in time. The bride arrived in an antique launch and eighty guests poured into the new boathouse to attend the ceremony. They spread out onto the wraparound deck and filled the spacious screen porch. It was a grand celebration and a fitting inauguration for the boathouse called Charing Cross.

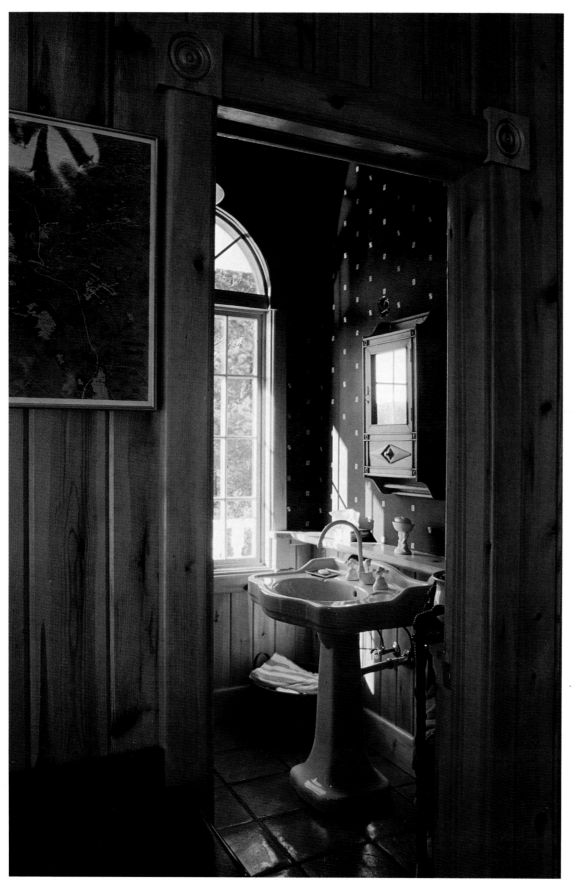

Even the bathroom is bright and breezy, with a large domed window overlooking the lake.

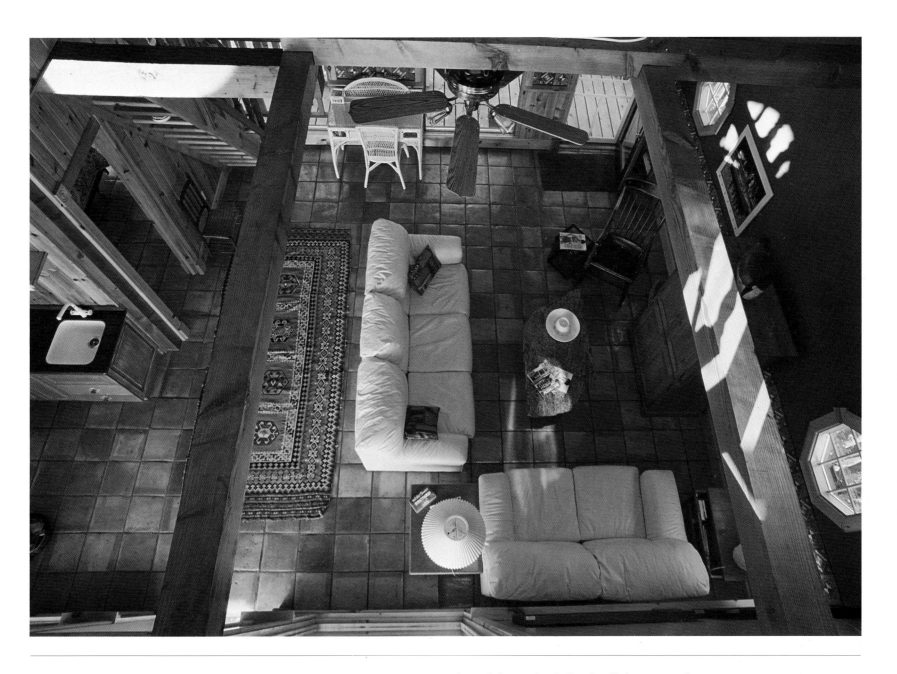

Viewed from the loft, the living room is
anchored by two leather sofas and a
Muskoka rock table. The granite slab was
left over from the stone walkway. Rather
than let the landscapers crack it into pieces,
the owners built a wooden base and turned
it into a coffee table.

The deep eaves and carved wooden rafter ends are balanced by a turned railing on four sides of the boathouse. Some of the gingerbread trim came from an old porch that was being removed from Cranberry House, a vintage Bala hotel.

Afternoon sun warms the swimming dock (viewed from the boathouse deck).

An unusual perspective. This photograph,
taken through the rear window of the
boathouse, shows the interior as well
as a reflection (from the glass) of the
shoreline behind it.

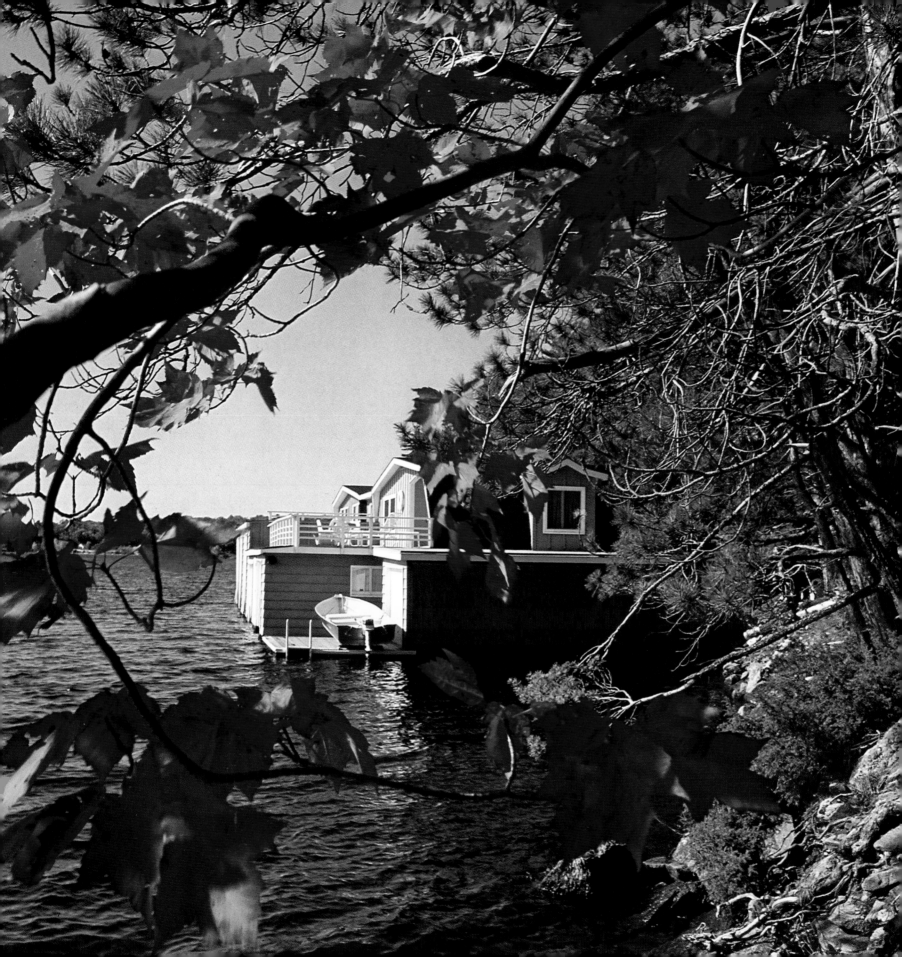

# THE WALKER COLLECTION

L A K E   M U S K O K A

There are boaters and there are boat collectors. In the small and exclusive latter group, Murray Walker is well known. His huge boathouse on Lake Muskoka shelters a bevy of antique boats ranging from *Floss*, a 19-foot Minett built in 1909, to a Gold Cup racing boat, the *Rainbow IX*, that once belonged to Howard Hughes. Walker likes to collect boats that represent a decade — the oldest, best or most distinctive boats of a particular time. As a result, the inside of his boathouse is a sort of history of boat evolution. He has a wonderfully preserved birchbark canoe; the oldest disappearing-propellor ("dippy") boat afloat; and The *Clarie II*, a stiletto-hulled racing boat that he first saw at Lake Simcoe when he was eight years old (he waited until he was thirty-six to buy it). "I look for a long time before I buy," says Walker, "because I like to have variety in the collection. I think it would be boring

to have only runabouts, for instance, from every era."

Walker's boathouse is designed for winter storage of his collection. Some of the slips are equipped with automatic hoists that pull the boats up in slings; others are hoisted manually and placed on big timbers. The engines are drained and winterized, and all chrome is coated with a thin film of motor oil. Soft cotton towels are used to clean the shiny wood. A bubbler system, with four or five bubblers, or propellors, keeps the water around the boathouse circulating and free of ice through the winter. Even hanging in their slings the Walker collection is a delight to see. "People always want to touch these boats — almost as if they're testing to see if the varnish is wet," says Murray. Perhaps that's why on one wall of his boathouse there is a sign that reads: "Please do not caress."

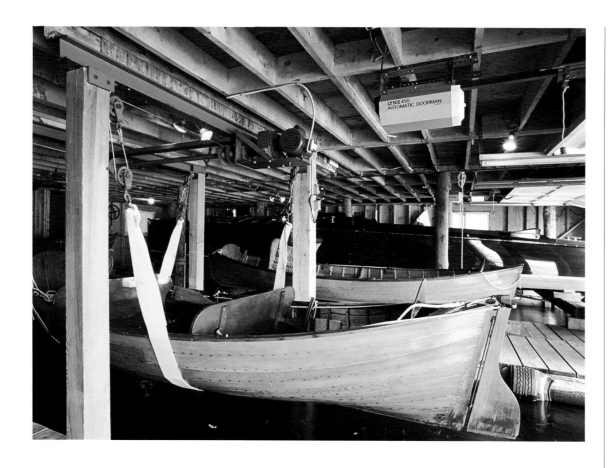

In preparation for winter, the Walker collection is either hoisted in automatic slings or raised up on timbers inside the boathouse.

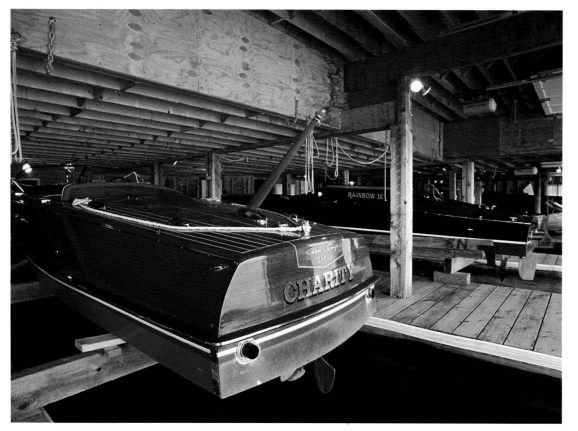

Murray Walker's wonderful old steamboat the *Traveller* was built in 1894 and converted to gas in 1905. Next to a birchbark canoe, the *Traveller* is the oldest boat in his vast collection. A carefully inscribed wooden plaque mounted on the boathouse wall depicts the *Traveller's* history. Walker uses all his boats, including the *Traveller*, which is perfect for taking large groups out on lake tours.

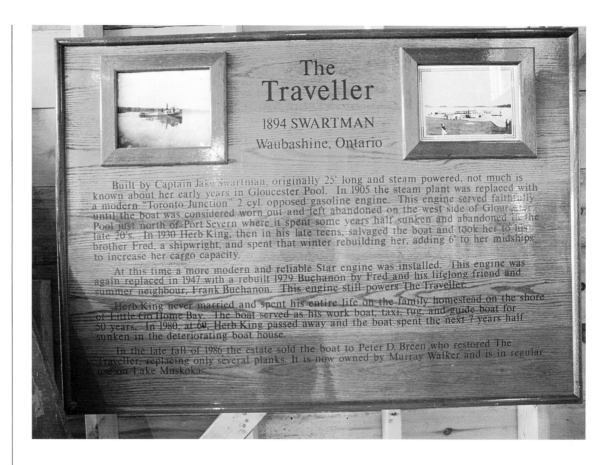

## The Traveller

### 1894 SWARTMAN
### Waubashine, Ontario

Built by Captain Jake Swartman, originally 25' long and steam powered, not much is known about her early years in Gloucester Pool. In 1905 the steam plant was replaced with a modern "Toronto Junction" 2 cyl. opposed gasoline engine. This engine served faithfully until the boat was considered worn out and left abandoned on the west side of Gloucester Pool just north of Port Severn where it spent some years half sunken and abandoned in the late 20's. In 1930 Herb King, then in his late teens, salvaged the boat and took her to his brother Fred, a shipwright, and spent that winter rebuilding her, adding 6' to her midships to increase her cargo capacity.

At this time a more modern and reliable Star engine was installed. This engine was again replaced in 1947 with a rebuilt 1929 Buchanon by Fred and his lifelong friend and summer neighbour, Frank Buchanon. This engine still powers The Traveller.

Herb King never married and spent his entire life on the family homestead on the shore of Little Go Home Bay. The boat served as his work boat, taxi, tug, and guide boat for 50 years. In 1980, at 69, Herb King passed away and the boat spent the next 7 years half sunken in the deteriorating boat house.

In the late fall of 1986 the estate sold the boat to Peter D. Breen who restored The Traveller, replacing only several planks. It is now owned by Murray Walker and is in regular use on Lake Muskoka.

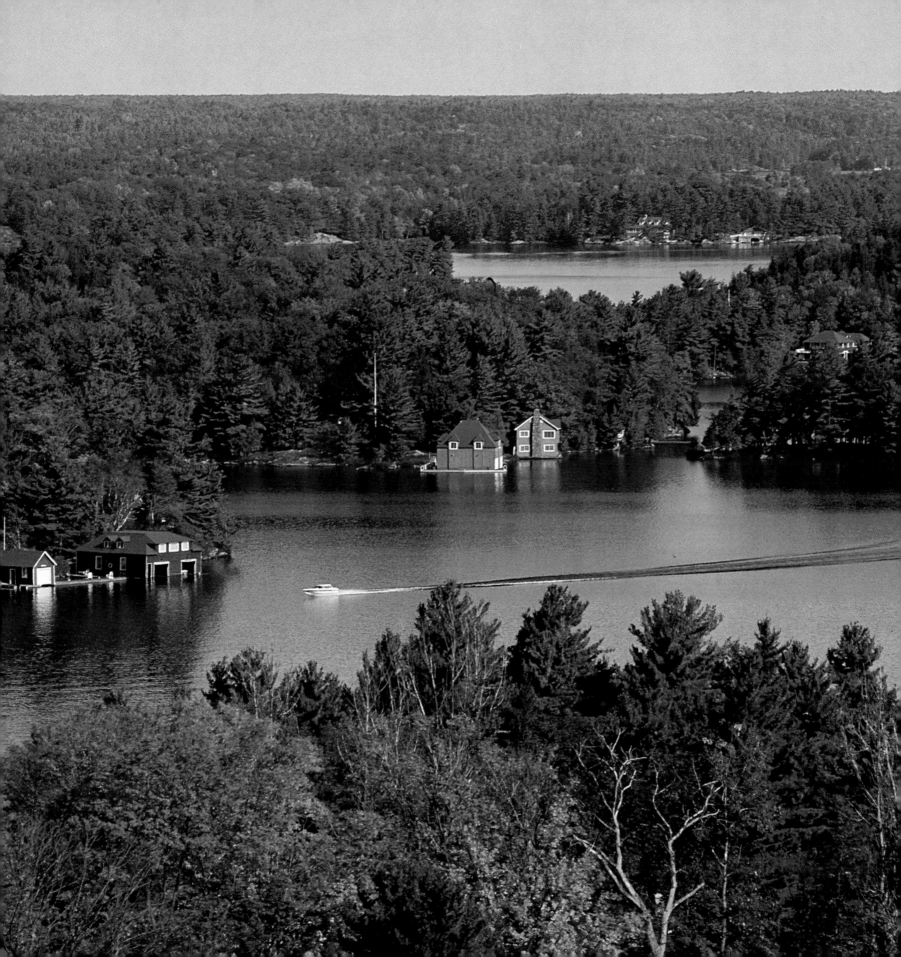

# AT THE WATER'S EDGE

Located on Lake Rosseau, Bracken Island is joined to its smaller neighbouring island
by a breakwater and walkway. The original peaked section of the boathouse was built in 1906 to house
two Minett-Shields boats, the *Sea-Horse* and the *Blue Streak*. New owners added four more slips to the boathouse,
as well as a second floor. Today the upper storey is a large recreation area with a slippery-floored broomball
court and a ping-pong table. The long roof, which stretches almost 100 feet out from the shore, has two shed
dormers enlivened by multipaned windows and flower boxes brimming with pink impatiens.
A handsome rowing skiff fits perfectly into the narrow slip closest to shore.

The marina at Baysville on Lake of Bays,
once the base for Cameron Peck's
flotilla of antique boats.

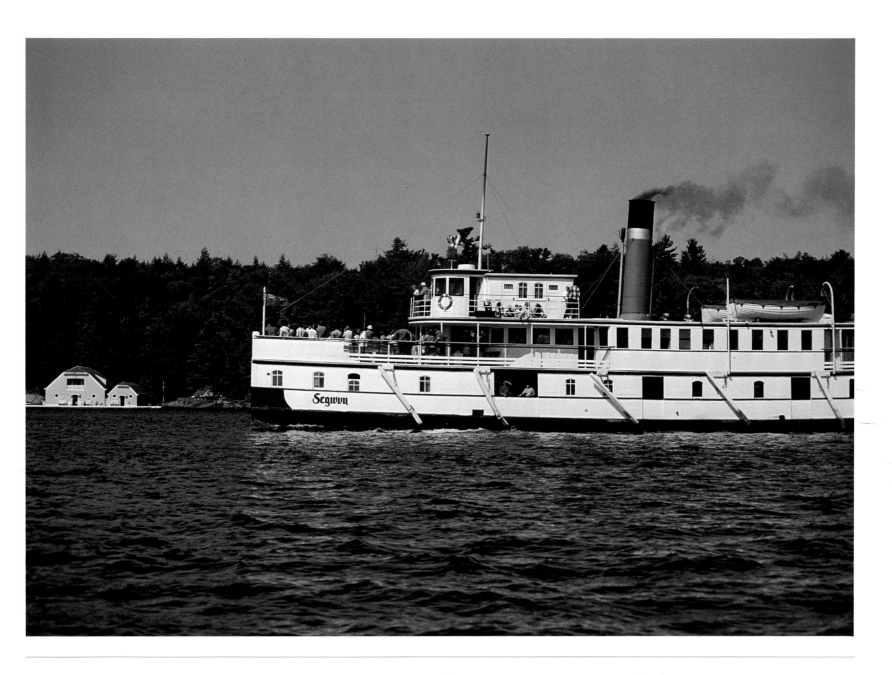

The RMS *Segwun* steams past the Clemson boathouses. The matching grey-and-white boathouses were designed by Pittsburgh architect Brendan Smith. A huge ballroom was located in the upper level of the large boathouse.

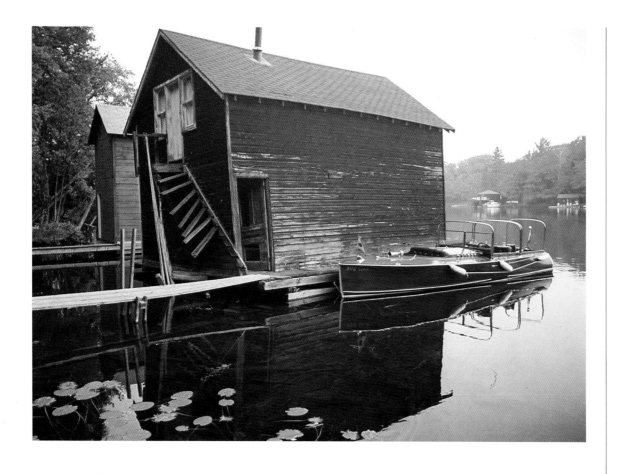

Some Muskoka boathouses have seen better days.

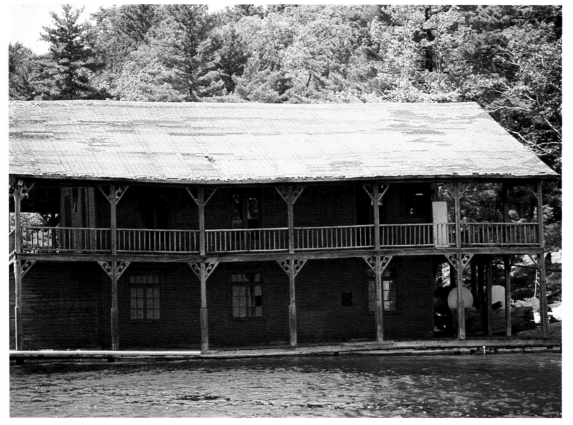

The sailboat boathouses belonging to the Osler Family on Lake Rosseau are a tribute to the ingenuity of Britton Osler and the carpentry skills of Windermere builder Henry Longhurst. Although no longer used to house sailboats, they were built in 1935 for a St. Louis-class sloop and two dinghies.

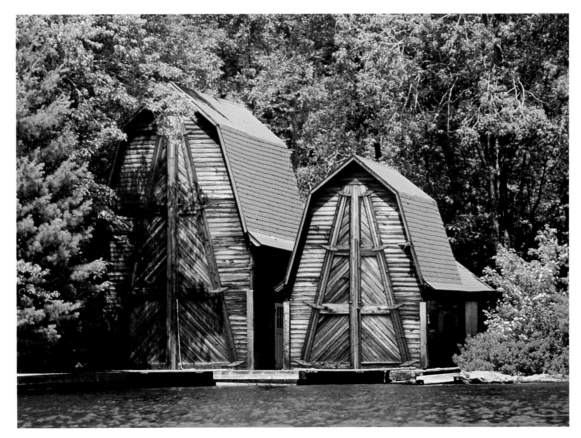

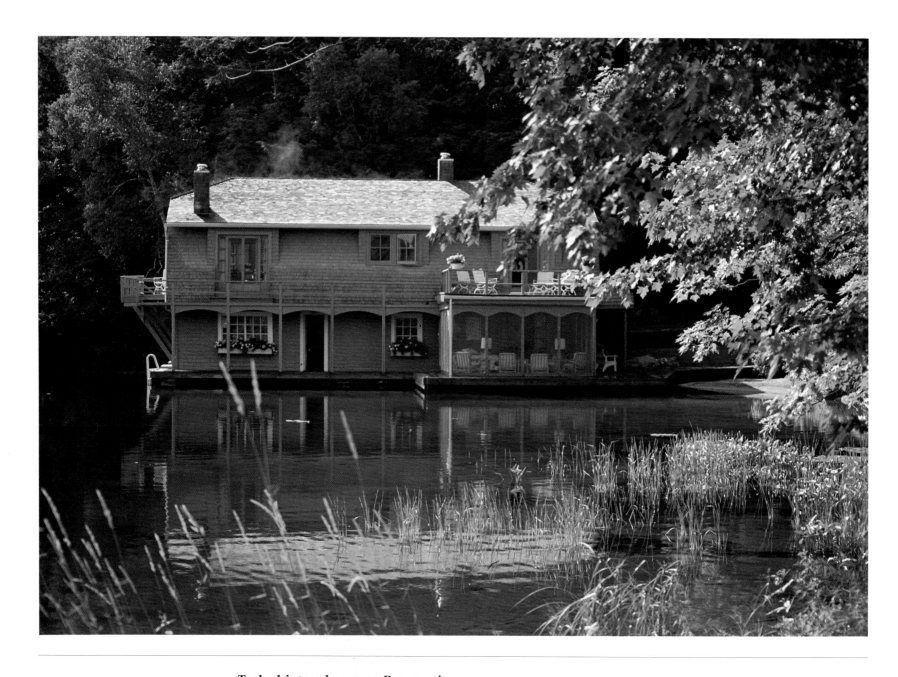

Tucked into a bay near Beaumaris,
this boathouse has a screened veranda
at water level.

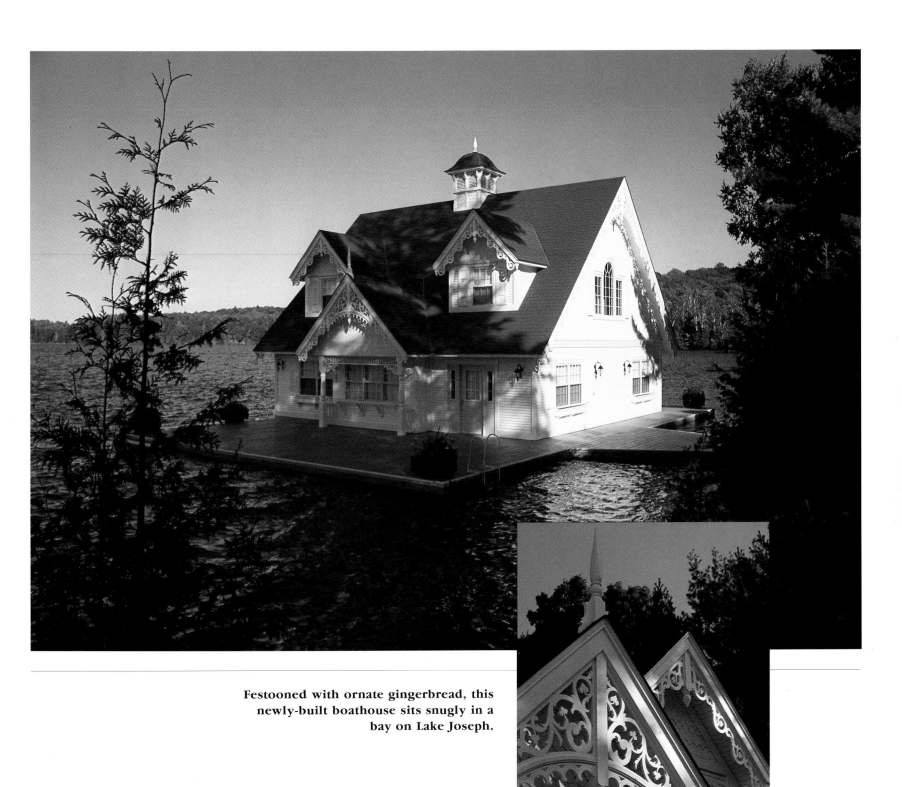

**Festooned with ornate gingerbread, this newly-built boathouse sits snugly in a bay on Lake Joseph.**

Old steamer hulls are flipped over, shingled and given new life as storage sheds in Milford Bay on Lake Muskoka.

Peaceful symmetry on Lake of Bays.

A bridge connects Bass Island and its
boathouse to a smaller island named Japan.
The boathouse, built in 1882, is one of the
oldest on Lake Rosseau.

Amber light shining through leaded windows at John and Madeline Fielding's whimsical boathouse, Todmorden, near Mortimer's Point on Lake Muskoka.

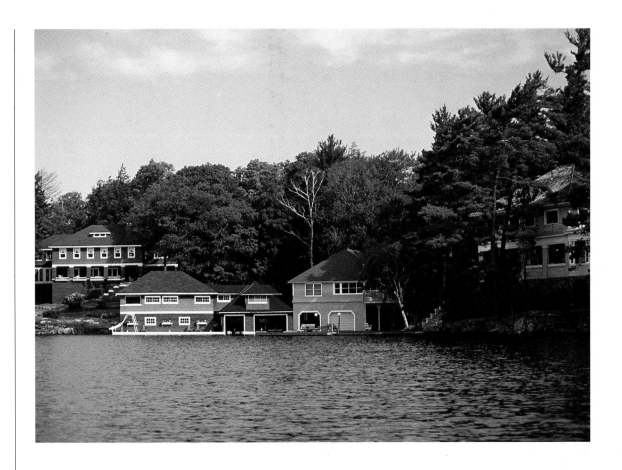

Boathouses line the shore near
Beaumaris on Lake Muskoka.

Bobbing in its Beaumaris berth is the
*Robin Adair*, a 1927 Ditchburn.

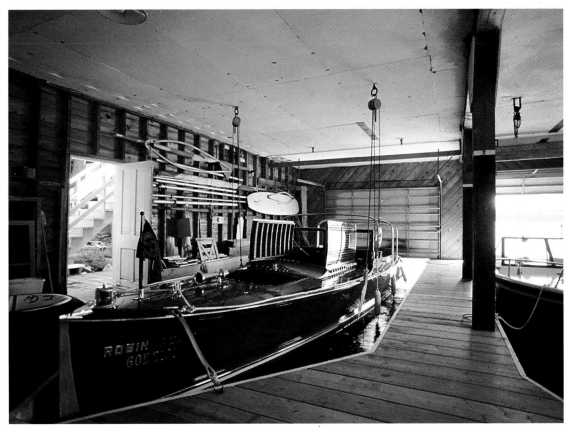

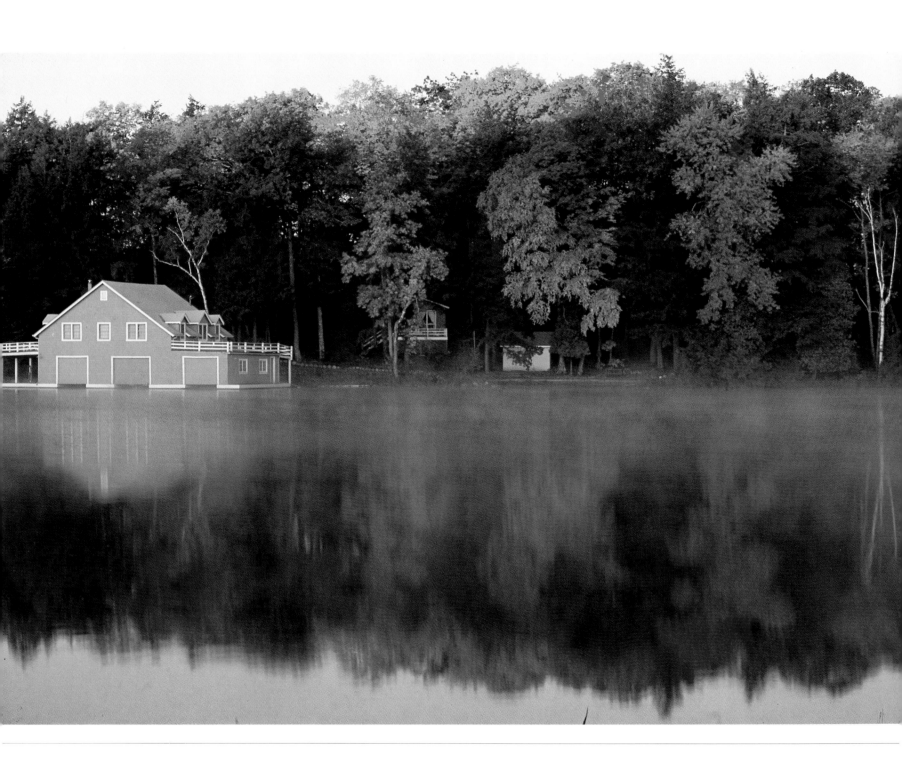

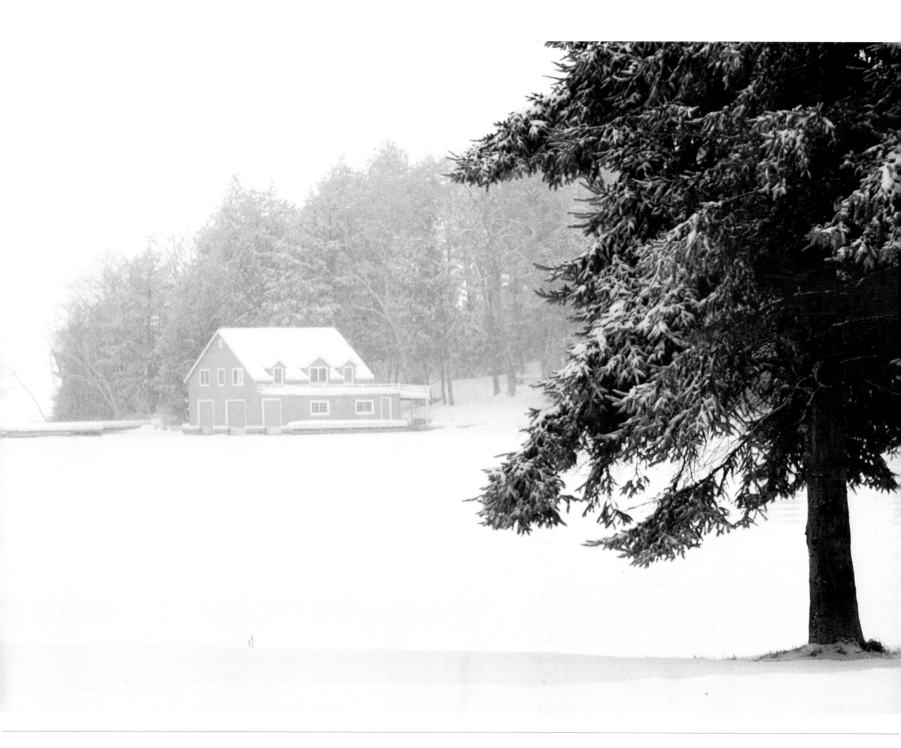

**Autumn turns to winter near Milford Bay,
Lake Muskoka.**

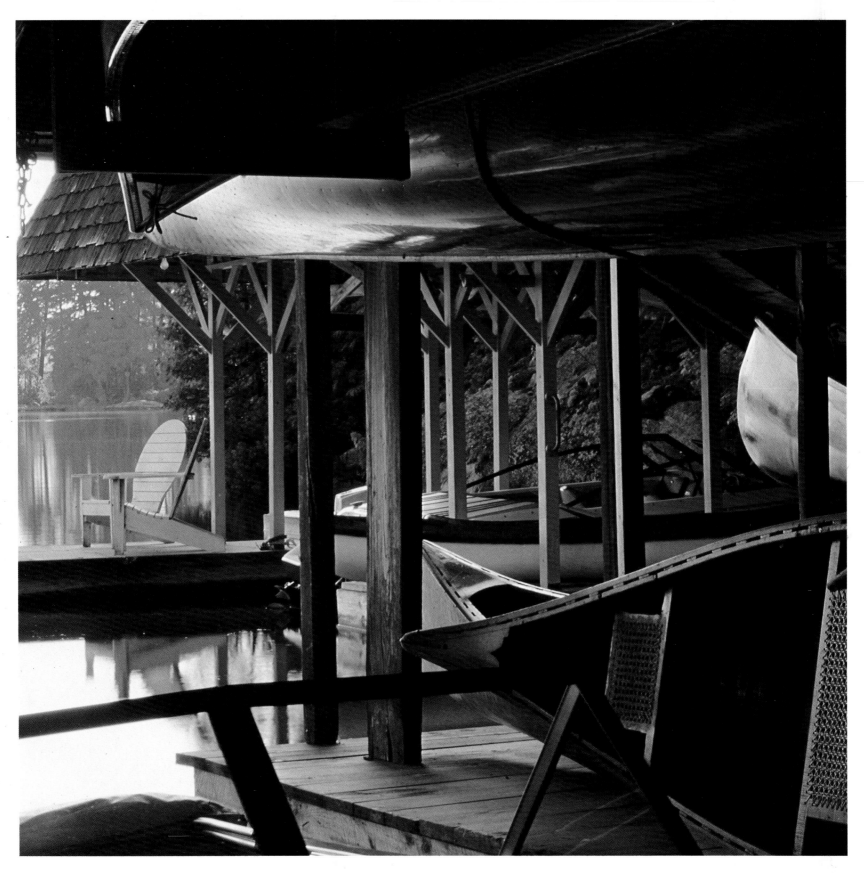

Boat storage at the Penney lumbermill, Lake Rosseau.